The Photoshop CS5 PocketGuide

Brie **Gyncild**

Ginormous knowledge, pocket-sized.

Peachpit Press

The Photoshop CS5 Pocket Guide
Brie Gyncild

Peachpit Press
1249 Eighth Street
Berkeley, CA 94710
510/524-2178
510/524-2221 (fax)

Find us on the Web at: www.peachpit.com
To report errors, please send a note to: errata@peachpit.com

Peachpit Press is a division of Pearson Education.

Editor: Rebecca Gulick
Production Editor: Tracey Croom
Copyeditor: Elizabeth Kuball
Proofreader: Liz Welch
Compositor: Myrna Vladic
Indexer: Valerie Haynes Perry
Technical Reviewer: Jean-Claude Tremblay
Cover and Interior Design: Peachpit Press

ISBN 13: 978-0-321-71432-9
ISBN 10: 0-321-71432-6

9 8 7 6 5 4 3 2 1

Printed and bound in the United States of America

For Sandy, of course.

Acknowledgments

My name may be on the cover, but many people played a part in producing this book. Jean-Claude Tremblay's capable technical review made the chapters more accurate and more coherent, Elizabeth Kuball and Liz Welch ensured the text was clean, Valerie Haynes Perry composed the index to help you find what you need, and Tracey Croom and Myrna Vladic kept production running smoothly. If you judged the book by the cover, you relied on Cory Borman's good work. I am particularly grateful to Rebecca Gulick for inviting me to write the book, providing me the resources I needed, and making the whole process a pleasure.

Thank you to Doña and Verne, Andrew, Colleen, Sandy, Jinx, Pico, Longfellow, Nada, and Belly for letting me share their photos with you.

As always, I am indebted to Sandy, who put up with my working long hours, helped me brainstorm structural and technical issues, and shared my enthusiasm when everything fell into place.

About the Author

Brie Gyncild aims to make technical information accessible to those who need it. She's written books on many Adobe applications, including Adobe Photoshop, Adobe Photoshop Elements, Adobe InDesign, and Adobe After Effects. Brie lives in Seattle with her partner, their cats, and an overgrown garden.

Contents

Introduction

Adobe Photoshop CS5 packs a lot of power into a single application. All that power can make your life easier and your photos stunning, but it can also be a bit overwhelming. This book is intended to help you accomplish whatever you need to do in Photoshop without requiring too many swear words or raising your blood pressure. As you get more comfortable with Photoshop and the concepts involved, you'll likely tackle more challenging photo corrections and find yourself editing photos with increasing confidence.

Keep in mind that this is a pocket guide to Photoshop, not a photography primer. You're probably a much better photographer than I am, and there are countless books and resources out there to help you develop photography skills. Likewise, this book isn't a comprehensive manual for the

Photoshop application. In fact, I don't cover any of the additional features in Photoshop Extended (such as 3D features) in this book.

The chapters are organized primarily by task. You can read the book from start to finish, or you can pick it up when you need to perform an unfamiliar task or try to make sense of a feature that has you confused. It's completely up to you. You'll have the best success working with Photoshop overall, though, if you start with the basics, get comfortable with the fundamental concepts (such as working with panels in general, manipulating layers, creating selections, and so forth), and build on success. Therefore, if you're new to Photoshop, I recommend you read through the first couple of chapters in order to learn a bit about the Photoshop paradigm before you jump around too much.

It's most fun to learn when you feel free to explore and experiment, especially in an application with as many gizmos and gee-whiz features as Photoshop. My life got much better when I started routinely working with copies of my images, preserving the original. Knowing that those precious pixels are safe means you can wander down any path you like without risking your masterpiece, whether it's the photograph of your daughter's first experience with ice cream or a striking sunset over a Venetian canal.

1

Meet Photoshop

Adobe Photoshop has long been a treasured tool for professional photographers, but its reputation extends far beyond industry circles. To the lament of Adobe's legal department (and, most likely, the glee of its marketing folks), the brand name has become a verb in casual conversation. Amazing images often prompt the question, "Did you Photoshop that?"

There's good reason that Photoshop has become so ubiquitous. Photoshop provides the tools you need to manipulate a photograph in almost any way you can imagine. From simple tasks, such as removing red eye or cropping an image, to more complex procedures, such as making creative distortions or merging parts of images with each other, Photoshop offers a full range of features to meet the needs of

professional and amateur photographers, as well as family historians, graphic designers, and tabloid layout artists.

While it may have been a straightforward program at its inception, Photoshop has grown in complexity with each new release. It's chock-full of features, but that abundance can be a bit intimidating to a newcomer. However, even a beginner can take advantage of much that Photoshop has to offer from day one. Take the time to tour the user interface and get familiar with some of the terms so that you'll be able to make sense of instructions later in this book, in Photoshop Help, or anywhere else you turn for assistance. Then, dive in!

The Photoshop Work Area

If you've worked with other Adobe applications, especially Adobe InDesign or Adobe Illustrator, the Photoshop work area will be familiar. There's plenty going on in this window, too, with panels and tools tucked into their storage spots. At the top are the menu bar, the application bar, and the options bar. On the left, the Tools panel includes most of the tools in Photoshop. On the right is the panel dock, home to panels that give you quick access to settings and options for many different tasks.

As in most applications, you'll find most of the main commands in the menu bar. The application bar, similar to those in other Adobe Creative Suite applications, makes it easy to jump to Adobe Bridge or open the Mini Bridge panel, arrange open documents, and change workspaces. The settings in the options bar change to include whatever is relevant for the tool you've selected in the Tools panel.

Figure 1.1

The Photoshop work area

A. Application bar

B. Launch Bridge icon

C. Launch Mini Bridge icon

D. Workspace Switcher

E. Menu bar

F. Options bar

G. Tools panel

H. Image window

I. Document size

J. Panel dock

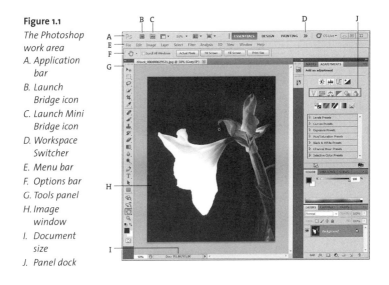

Tools

Photoshop includes dozens of tools. You'll use some of them frequently, and others you may never have reason to use. They're all kept handy for you in the Tools panel. However, if they were all visible at once, you wouldn't have much room left onscreen to work with your image. To keep the Tools panel tidy, tools are often grouped together. If a tool icon has a little black triangle in the lower-right corner, more tools are hidden under it. You can access hidden tools by clicking and holding on a tool until its entire group is listed in a menu.

Figure 1.2

Click and hold on a tool to see other tools grouped with it.

Figure 1.3

Tools are grouped by function in the Tools panel.

Move tool

Selection tools

Cropping and slicing tools

Eyedropper and measurement tools

Healing tools

Painting tools

Stamp tools

History brush tools

Eraser tools

Fill tools

Blur, sharpen, and smudge tools

Dodge and burn tools

Pen tools

Type tools

Path selection tools

Shape tools

3D tools (Photoshop Extended only)

Navigation tools

Foreground and background colors

Many of the tools in the Tools panel are covered in this book. The 3D tools, which are available only in Photoshop Extended, aren't included in this pocket guide; the 3D features are cool, but they're beyond the scope of this book.

When you select a tool, its settings appear in the options bar. For example, if you select the Brush tool, options such as Opacity and Painting Mode appear in the options bar. If you select the Crop tool, you can enter height, width, and other dimensions in the options bar.

Panels

Much of the work you do in Photoshop involves interacting with panels. Panels are collections of settings and options that are related to specific kinds of tasks. In addition to the settings in the panel itself, each panel has its own menu (accessible from the icon on the right side of the panel title bar), which contains commands specific to that panel.

For example, the Layers panel lists all the layers in the document, in their stacking order, and shows whether each layer is visible or hidden, locked or unlocked, and which opacity, blending mode, effects, and other attributes are applied to the layer. If you want to make a change to a layer's settings, you do it in the Layers panel.

Figure 1.4
Each panel has a tab and a menu, and most have icons at the bottom.

Panel tab

Panel menu

Delete panel item

Create new panel item

Likewise, the Swatches panel contains color swatches, and its panel menu contains commands that let you create, load, save, and otherwise modify swatches; the Paragraph panel affects paragraph-level attributes for text; the Brush panel displays all the settings you can change for brush attributes; and so on.

By default, most panels are connected to each other and attached to the right side of the window, in the panel dock. But you can pull a panel out of the dock so that it floats—just drag its tab away from the dock. You can also change how panels are grouped by dragging a panel's tab from one panel group to another.

Figure 1.5
Drag a panel by its tab to remove it from the dock.

Figure 1.6
Panels not attached to the dock are called floating panels.

Workspaces

A Photoshop workspace is a configuration of windows, panels, menu commands, and shortcuts, usually designed for a particular set of tasks. The default workspace is called Essentials. To select a different workspace, click its name in the Workspace Switcher in the application bar or choose Window > Workspace, and select the workspace you want to use.

Figure 1.7
*Select a new
workspace to
change the panel
configuration.*

| ESSENTIALS | DESIGN | PAINTING | » |

	Essentials
✓	Design
	Painting
	Photography
	3D
	Motion
	New in CS 5
	Reset Design
	New Workspace...
	Delete Workspace...

You can create your own customized workspaces, too. That's a great idea if you find you frequently open the same panels or if you prefer to position them outside the panel dock. To create a custom workspace, first position the panels where you want them, and then choose Window > Workspace > New Workspace.

The preset workspaces in Photoshop CS5 are fairly self-explanatory:

■ The 3D workspace (in Photoshop CS5 Extended) is for working in three dimensions.

■ The Design workspace features panels you might need for graphic design and layout (including text formatting).

■ The Motion workspace features panels for creating animation and interactivity.

■ The Painting workspace makes the Brush and Brush Presets panels prominent.

■ The Photography workspace focuses on panels you'd need to work with masks, channels, and paths.

tip If you make changes to the workspace as you work, Photoshop stores those changes. For example, if you're in the Essentials workspace and you pull a panel out to float, the next time you return to the Essentials workspace, that panel will still be a floating panel. To return to a default workspace, choose Window > Workspace > Reset [workspace name].

Navigating Images

To make changes to an image, you need to be able to see it. Sometimes that means zooming in to focus on a tiny detail, and sometimes it means zooming out to get a feel for the big picture. There are several ways to move in, out, or around an image. Which one you use depends on what you're trying to accomplish, but it's largely a matter of personal preference. Take each method for a test run to see which seems most intuitive to you.

The Zoom tool

The Zoom tool looks like a magnifying glass. Select it in the Tools panel and then click on the image to zoom in, increasing the magnification. Or, just click and hold the mouse on the image to zoom in. To zoom out, press the Alt (Windows) or Option (Mac OS) key as you click, or as you click and hold.

Figure 1.8
Click the Zoom tool to zoom in.

Figure 1.9
Press Alt or Option to zoom out with the Zoom tool.

If Scrubby Zoom is selected in the options bar, simply drag the Zoom tool to the right to zoom in or to the left to zoom out. If Scrubby Zoom isn't selected, you can drag the Zoom tool around an area in the image to zoom in so that the area you selected fills the image window.

Double-click the Zoom tool in the Tools panel to jump to 100 percent view.

Figure 1.10
Drag a marquee around a region to zoom into it.

Figure 1.11
The area you selected fills the image window (horizontally, in this case).

When the Zoom tool is selected, you can also click a button in the options bar to quickly zoom in to see the actual pixels, fit the image on the screen, fill the screen with the image, or view the image at its print size.

> **tip** What's the difference between Fit Screen and Fill Screen? Fit Screen keeps the image proportional so that you can see the entire thing. Fill Screen fills the screen with the image's shorter dimension (width or height), so you may not see all of it, but you see nothing but image!

Figure 1.12 *Click a button in the options bar to change the zoom setting.*

Commands

The View menu includes several commands that change the magnification of the image. You can choose a command to zoom in, zoom out, fit the image on the screen, see the actual pixels, or see the image in the size it will print.

The Navigator panel

If you want to see detail while keeping an eye on the overall image, you may find the Navigator panel handy. To open the panel, choose Window > Navigator.

Figure 1.13
The red frame in the Navigator panel shows you what you're seeing in context.

A red frame indicates the part of the image that is currently in view. Drag the red frame within the Navigator panel to change which area of the image you're viewing in the document window. Drag the slider to increase or decrease the image magnification.

The Hand tool

As you might have guessed, the Hand tool looks like a hand. You use it to pan across the image, as if you were using your hand to push the image across the screen. Just select the tool, click on the image, and drag

in the direction you want to move it. When the Hand tool is selected, the options bar displays the same view buttons as when the Zoom tool is selected, although it doesn't display some of the other options.

Opening Files

In order to make use of panels, tools, or navigation methods, you need to have a file open. The traditional way to open a file is to use the Open command. Choose File > Open, select the file you want to open, and click Open.

Figure 1.14
Select the file to open in the Open dialog box.

The native file format for Photoshop is PSD, which stands for Photoshop document, and you'll have the most flexibility if you work in PSD format. But you can open just about any kind of graphic file in Photoshop, including TIFFs, JPEGs, PDFs, PNGs, and a whole host of others.

tip To see which file formats you can open in Photoshop, choose File > Open, and then review the list in the Files of Type menu in the dialog box.

However you open a file, I recommend immediately saving a copy to work with, preferably in PSD format. When you work with a copy, you can make any changes you like without affecting the original. That way, if you want to use the image for something else later, or if you don't like the changes you made, you can return to the original and start over.

To save a working copy:

1. Choose File > Save As.

2. Select Photoshop (*.PSD, *.PDD) from the Format menu at the bottom of the Save As dialog box.

3. Name the file something you'll recognize. It's often easiest just to add " _working" to the original filename.

4. Click Save.

Figure 1.15

Save a copy of your image to ensure you can return to the original later.

Opening files using Bridge or Camera Raw

If you want to preview images so that you know which one you're opening, take advantage of Adobe Bridge CS5, which is included with Photoshop CS5. Bridge is especially handy if your photos have obscure names, such as P6320057.jpg. You can import photos directly from your camera or a card reader into Bridge, but Bridge also lets you organize and preview any file on your computer.

Figure 1.16

Find the image you want to work with in Adobe Bridge.

In Bridge, you can also open images in Adobe Camera Raw, where you can make edits before you even get to Photoshop. When you're done editing in Camera Raw, click Open Image to take the image, with all its changes, directly to Photoshop.

Figure 1.17
After editing images in Camera Raw, open them in Photoshop.

To learn more about Camera Raw, see Chapter 5. To learn about working with Bridge, see Chapter 12.

Using the Mini Bridge panel

New in Photoshop CS5 is the Mini Bridge panel. It's a lot like having Bridge within Photoshop itself. To open the panel, choose Window > Extensions > Mini Bridge, or click the Launch Mini Bridge icon in the application bar.

You can preview images within the Mini Bridge panel and then just double-click them to open them. To see a full-screen preview of an

image, select it in the Mini Bridge panel, and then press the spacebar.
Press the spacebar again to return to Photoshop.

Figure 1.18

*Mini Bridge
lets you browse
through
images without
having to leave
Photoshop.*

2

Laying the Foundation

The urge to dig in and start doing is understandable, but it's not always advisable. Sure, you could fumble your way through many Photoshop techniques and possibly achieve the results you want. But you'll enjoy the experience more, and work much more gracefully, if you understand some of the concepts at the core of Photoshop use. Of course, that's why this chapter is here, early in the book, so you won't be scratching your head in puzzlement later.

Bitmaps and Vectors

Photoshop was originally created to work with bitmap images, but you can also work with vector artwork. A *bitmap* or *raster* image is based on a grid of pixels, with each pixel assigned a particular location and color value. Pixels are ideal for working with photographs or other continuous-tone images, because they can represent subtle gradations in color and shade.

There is a downside to working with pixels, though. When you have a specific number of pixels, scaling an image to a larger size means either Photoshop has to guess what the additional pixels would be or, if you keep the same number of pixels, each pixel is larger and you lose the subtleties in the original. When you scale an image to a smaller size, Photoshop discards pixels, which can give you less-than-desirable results as well.

The alternative to bitmap, or pixel-based, images are vectors. *Vector* graphics are composed of lines and curves that are defined mathematically. Because they're not created pixel by pixel, you can resize vector graphics up or down without losing their crispness. When vector graphics are appropriate for your artwork, they're great. Rely on vectors for text and illustrations, such as many logos. But stick with bitmaps and their ability to display subtle gradations when you work with continuous-tone images, such as photographs. Sometimes, to work with vector artwork in Photoshop, you need to convert it to a bitmap by rasterizing it.

tip If you find bitmaps and vectors confusing, try thinking about them this way: Bitmaps give you information pixel by pixel, whereas vectors give you information line by line. For example, if you wanted directions to the grocery store, a bitmap would tell you to go one foot forward and then another foot forward and then another foot forward, and so one. A vector would say "Go straight till you get to the gas station. Then, turn right and continue until

you come to the next major intersection." If you were to change the scale of the pixel-based map, the number of feet would no longer work, but because the gas station and intersection are relative landmarks, they would move proportionally when you scaled the vector map.

Image Resolution

When you're working with a bitmap image, image resolution is key.

The *image resolution* is the number of pixels along the width and height of an image, commonly measured in pixels per inch (ppi). For example, a common image resolution is 300 ppi, which means the image is 300 pixels wide and 300 pixels high, for a total of 90,000 pixels of data.

Because each pixel contains specific information in a bitmap image, it's good practice to think ahead and work with images that are in the resolution in which you'll ultimately want to print or publish. Generally, though, you're better off starting with a higher resolution (which means you have more data) and scaling down than you are starting with a lower resolution and scaling up, which would require Photoshop to manufacture new pixels.

Color Modes

For most images, it makes sense to work in RGB color mode until you prepare to print. Then, if you're printing professionally, convert to CMYK color mode. Let's take a look at color modes.

The *color mode* (Grayscale, RGB, CMYK, Lab, and so on) determines how many colors—and which colors—you can use in an image. It also determines how many color channels are available. Additionally, the bit depth determines how many colors are available on each channel. A broader

range of colors and a larger number of color channels give you more colors to choose from in your image, but they also increase the file size.

When you first open an image in Photoshop, its color mode is usually either RGB or Grayscale. You can easily see its color mode and bit depth in the document title bar. The color mode and bit depth (in bits per channel) are in parentheses.

Figure 2.1
The title bar displays the filename, as well as its color mode and bit depth.

Understanding bit depth

What's a bit, anyway? It's a unit of color information. The number of bits determines how many possible color options are available to each pixel. If you had a 1-bit image, each pixel could be either black or white.

Today, most images are 8-bit. In an 8-bit image, each pixel can have any of 2^8, or 256, colors, in each channel. The greater the *bit depth* (bits per channel), the more information is stored for the image. Higher bit depth can result in a more accurate (and larger) image.

You can't change an image to 16-bit and magically create more data; that information needs to have come from the source. However, many scanners can scan 16-bit data, and some digital cameras claim to create 16-bit data. More likely, you'll get 12 or 14 bits.

The most common color modes in Photoshop are Grayscale, RGB, CMYK, and Lab, but you may have use for others occasionally, too. Briefly, the following are the color modes you may need to use in Photoshop:

- **Bitmap:** Don't confuse the Bitmap color mode with the definition of bitmap earlier in this chapter. A bitmap image, composed of pixels, can be in any color mode. But the Bitmap color mode has black pixels and white pixels, with no shades of gray and no other colors.

- **Grayscale:** When we talk about black-and-white images, we're usually actually referring to grayscale images. In the Grayscale color mode, an image contains black pixels, white pixels, and 254 shades of gray in between.

- **Duotone:** Duotone images are kind of artsy and can give you an old-timey effect or something much more radical. As the name suggests, a duotone image has two inks. Usually, one of the inks is black. You add another color, and Photoshop blends the two. Confusingly, the Duotone color mode is also used for monotones (one ink), tritones (three inks), and quadtones (four inks).

- **Indexed Color:** This color mode is designed to keep your file size small, but it can limit you creatively. With the Indexed Color mode, your image is restricted to a color palette you define. Indexed Color can work okay for images destined for the Web, but if you'll be printing, you're usually better off using a different color mode.

- **RGB Color:** Most digital images are in RGB Color mode. RGB stands for red, green, and blue, the additive colors that are displayed on computer monitors and televisions. Additionally, many desktop printers use RGB inks. It's usually best to work in RGB until you have to convert to a different image mode, because RGB provides a wide range of colors.

- **CMYK Color:** Most printed work, especially professionally printed output, is produced with CMYK (cyan, magenta, yellow, and black) inks. Because the range of colors produced by CMYK differs from that produced by RGB, you should typically convert the image to CMYK Color mode before printing professionally.

- **Lab Color:** Some photographers prefer to work in Lab Color mode, because it includes all the colors you can create in both RGB and CMYK modes. It's composed of three color channels: Lightness (also known as luminance), a (colors ranging from green to red), and b (colors ranging from blue to yellow). Lab colors are device independent, so they remain consistent on monitors, printers, and scanners.

- **Multichannel:** This mode is used for specialized printing, so you probably won't encounter it. In this mode, images contain 256 levels of gray in each channel. When you convert images to Multichannel mode, the original color channels become spot color channels.

Foreground and Background Colors

Those little swatches at the bottom of the Tools panel are very important. The one on the left is the current foreground color, and the one on the right is the current background color. Photoshop uses those colors when you paint, fill, erase, add gradients, or apply some special-effects filters.

Figure 2.2

The color swatches in the Tools panel determine the foreground or background color applied.

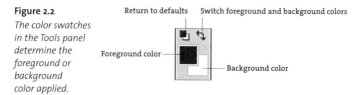

Return to defaults Switch foreground and background colors

Foreground color

Background color

The foreground color is used for color that's added to the image. The background color is what you erase to. Both are used when you create a gradient, which gradually shifts from one color to another. You can choose to apply either the foreground color or the background color when you increase the size of the canvas or perform other tasks that apply color.

By default, the foreground color is black and the background color is white. You can change the foreground or background color using the

Eyedropper tool, the Color panel, the Swatches panel, or by clicking the swatch and selecting a new color in the Adobe Color Picker.

To return the foreground and background colors to the defaults of black and white, respectively, click the Default Foreground and Background Colors icon in the Tools panel, or press D.

To swap the foreground and background colors, click the Switch Foreground and Background Colors icon in the Tools panel, or press X.

To select a new foreground or background color using the color picker:

1. Click the foreground or background color swatch in the Tools panel.

2. Select a new color in the Color Picker. You can select a color from the color display or enter values (HSB, RGB, Lab, or CMYK). You can also enter the hexadecimal value for the color (for example, the hexadecimal for white is ffffff).

3. When the new color swatch displays the color you want to use, click OK.

Figure 2.3
*Select a color in
the Color Picker.*

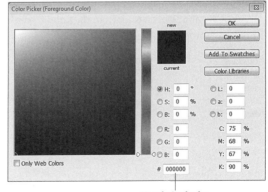

Hexadecimal value

tip You can select a color from a professional color library, such as PANTONE solid coated, as well. Click Libraries in the Color Picker, and then choose a library from the Book menu. Select the color you want to use, and click OK to return to the Color Picker.

To select a new foreground color using the Eyedropper tool:

1. Select the Eyedropper tool ![eyedropper icon].

2. Click on the color you want to sample.

To select a new background color using the Eyedropper tool:

1. Select the Eyedropper tool ![eyedropper icon].

2. Alt-click (Windows) or Option-click (Mac OS) on the color you want to sample.

To select a foreground or background color using the Color panel:

1. In the Color panel, select the foreground or background color box.

2. Select a color by dragging the sliders or entering values; click the color box again and select a color from the Color Picker; or click on the color ramp to sample a color.

Figure 2.4

You can also select a color using the Color panel.

To select a foreground or background color using the Swatches panel:

- Click a color in the Swatches panel to apply it to the foreground color, or Ctrl-click (Windows) or Command-click (Mac OS) a color to apply it to the background color.

Figure 2.5
Select a color you've already defined using the Swatches panel.

> **note** If the background color swatch is active in the Color panel, the Eyedropper tool samples colors for the background, and clicking a swatch in the Swatches panel applies it to the background color.

Making Selections

Sometimes you'll want to edit an entire image, adjusting its lighting or cropping it. But often, you'll want to make changes to specific areas of an image, copy part of an image into another file, or sharpen only a section. To make changes to a specific area of an image, you first have to make a selection.

Photoshop includes several selection tools, with strengths that make them appropriate for different scenarios. Here's a basic introduction:

- **Rectangular** and **Elliptical** **Marquee tools:** Use one of these tools to select a rectangular or elliptical area of an image. To select a perfect square or circle, press the Shift key as you drag the tool.

Figure 2.6

Use the Rectangular Marquee tool to make a rectangular or square selection.

Figure 2.7

Use the Elliptical Marquee tool to make an elliptical or circular selection.

- **Lasso tools:** The lasso tools create freehand selections, in any shape you like. The Lasso tool itself is completely flexible—just use it as if you were using a pencil to draw a shape. Use the Polygonal Lasso tool to click anchor points around an area; the tool joins the anchor points with straight lines. The Magnetic Lasso tool anticipates the selection you're trying to make and helps you keep the selection true to an object's edges.

- **Quick Selection tool:** The Quick Selection tool is often your best bet for making accurate selections quickly. As you paint with this tool,

Figure 2.8
The Quick Selection tool anticipates edges, so selections really are quick.

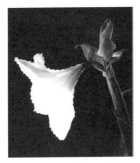

it automatically finds the edges to create a selection. It's great for selecting areas that contrast with the areas around them.

- **Magic Wand tool:** The Magic Wand tool selects pixels that are similar in color to the area you paint with it. You can change its settings so that it includes only contiguous pixels or all the pixels in the image that match the color criteria.

You can also choose Select > Color Range to select all the pixels in a color range, which can be useful if you need to select trees and grass, for example, or multiple brick buildings.

Active selections appear onscreen as animated dashed lines, often called "marching ants." Once you have a selection, you can do several things with it:

- **Reposition the selection itself, so that a different area of the image is selected:** Click in the middle of the selection and drag it where you want it, or press the arrow keys to nudge it into position.

- **Move the contents of the selection:** Select the Move tool, and drag the selection with it.

- **Copy the selection and move the duplicate:** Select the Move tool, and then press Alt or Option as you drag the selection.

- **Refine the edges of a selection:** Smooth or feather the edges of a selection by choosing Select > Refine Edge and then adjusting the settings.

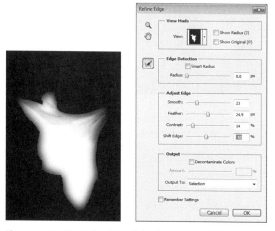

Figure 2.9 *Use the Refine Edge dialog box to smooth the edges of a selection and to preview it out of the context of the image.*

- **Apply an effect or make a change:** Anything you do when you have an active selection affects only the selected pixels.

- **Save a selection to use it later:** Save a selection as an alpha channel so you can easily access it later. This is especially helpful if you expect to use a tricky selection multiple times. To save an active selection as an alpha channel, choose Select > Save Selection, choose New from the Channel menu, name the new alpha channel, and then click OK.

- **Hide the marching ants without removing the selection:** Choose View > Show > Selection Edges. Choose it again to restore the visible selection border.

- **Deselect the area:** Choose Select > Deselect.

Figure 2.10

Save a selection as an alpha channel to retrieve it later.

Save Selection

── Destination ──
Document: jumping goldfish.jpg
Channel: New
Name: fishbowl

OK
Cancel

── Operation ──
◉ New Channel
◯ Add to Channel
◯ Subtract from Channel
◯ Intersect with Channel

Understanding channels

Layers contain the actual content and effects in your image. *Channels,* on the other hand, contain the image's color and selection information. They're always there, even if you don't work with them at all.

In an RGB image, there are four channels in the Channels panel: Red, Green, Blue, and RGB, which is the image composite. Similarly, in a CMYK image, there are five color channels: Cyan, Magenta, Yellow, Black, and the CMYK composite. You can make specific edits to any one channel or to any combination of the channels.

Figure 2.11

The Channels panel.

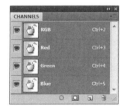

That's all well and good, but it really gets interesting when you start working with alpha channels. You can save selections in

(continued on next page)

Understanding channels (continued)

alpha channels, use alpha channels from one image in another, and convert alpha channels to spot-color channels. Alpha channels are 8-bit grayscale images, capable of displaying 256 shades of gray. You can edit a mask stored in an alpha channel using filters or painting or editing tools.

You can save a selection in an alpha channel either by choosing Select > Save Selection, or by clicking the Add a Pixel Mask button in the Masks panel (in which case Photoshop converts the active selection to a layer mask).

Figure 2.12

Save a selection as a pixel mask.

To use a selection you've saved in an alpha channel, choose Select > Load Selection. In the Load Selection dialog box, choose the channel's name from the Channel menu, and click OK. Alternatively, you can select the alpha channel, and click the Load Channel as Selection button at the bottom of the panel. At that point, the alpha channel is the only channel displayed, so you need to click the composite channel to see your image again. You can also just drag the alpha channel down onto the Load Channel as Selection button at the bottom of the Channels panel.

Working with Layers

When you first open an image file in Photoshop, it typically has just one layer, a background layer. As you work with the image, you or Photoshop may add more layers, each providing additional content or modifying the

content of existing layers. Layers let you work with one part of an image without affecting others.

The order of layers makes a big difference in the appearance of your image, determining whether certain objects are on top of or obscured by others. Think of layers as sheets of clear plastic stacked on a table, each with a different portion of a drawing. If you rearrange the sheets, different portions of the image may appear or be hidden.

You can reposition, show, hide, and make other changes to layers in the Layers panel. Choose Window > Layers to open the panel. To change the stacking order of layers, simply drag a layer to another position in the Layers panel.

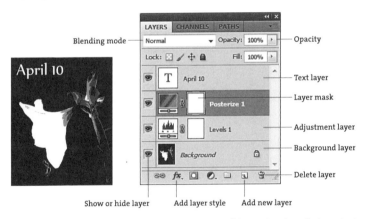

Figure 2.13 *How layers are arranged in the Layers panel determines how their content appears in the image.*

Photoshop includes special kinds of layers, such as text layers, which are created every time you add text, and adjustment layers, which let you make changes to your image without altering the actual pixels.

Nondestructive Editing

When you make edits to the image background layer, such as cropping the image or changing the lighting, you change the pixels themselves. Even though the changes may enhance the image, changing the pixels is called destructive editing. Once again, I strongly recommend working in a copy of an image so that you can always return to the original if you decide to take a different creative path. Even when you're working with a copy, though, it's convenient to retain flexibility. You can take advantage of several features that let you make nondestructive edits—that is, edits you can revisit, remove, and modify any time you want to.

Adjustment layers, for example, let you make adjustments to tonal levels, exposure, and other aspects of the image without affecting the original pixels. Instead, the changes are made on a separate layer that overlays the original. You can easily return to the adjustment layer to modify the settings and change the way it affects the image. You can even hide or delete the adjustment layer if you decide not to use the changes. The easiest way to add adjustment layers is by using the Adjustments panel. Choose Window > Adjustments to open it.

When you click an adjustment icon, the Adjustments panel changes to display the options for that adjustment layer. To add another adjustment layer, click the Return to Adjustment List button at the bottom of the panel.

tip By default, adjustment layers affect all the layers below them. However, you can limit the adjustment layer—or any other layer—to affect only the layer directly beneath it by creating a clipping mask. Make sure the adjustment layer is directly above the layer you want to affect. Then, select the adjustment layer, and click the Clip To Layer icon (third from the left) at the bottom of the Adjustments panel. (Alternatively, choose Create Clipping Mask from the Layers panel menu.) The adjustment layer is indented with a small arrow next to it, and the name of the layer it affects is underlined.

Figure 2.14

Add adjustment layers using the Adjustments panel.

Figure 2.15

The Adjustments panel changes to display options for the adjustment layer you're adding. Click the arrow in the lower-left corner to return to the default Adjustments panel.

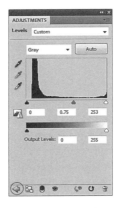

Figure 2.16

When you create a clipping mask, the top layer is indented in the Layers panel, and the name of the layer clipped to it is underlined.

Likewise, Smart Filters make changes to the image without modifying the pixels themselves. As with adjustment layers, you can make changes to them at any time, even turning them off if you don't want to use them anymore. Smart Filters work only with Smart Objects, so in order to use them, you need to first convert a layer to a Smart Object. Turn to Chapter 7 to learn more about Smart Filters.

Any edits you make in Camera Raw are also nondestructive. Instead of altering the image itself, Camera Raw writes the changes as metadata that it attaches as a "sidecar" XML file, which travels with the image. You can return to Camera Raw to revise or remove the edits you made at any time. See Chapter 5 to learn about working in Camera Raw.

tip You can also use layer styles (described in Chapter 7) and masks (described in the next section) to edit nondestructively.

Masks

When you paint a wall, you use masking tape to protect the trim and anywhere else you don't want to accidentally paint. Masking in Photoshop works much the same way: the area you mask is protected from the changes you make, whether you're painting or applying effects. Adjustment layers automatically come with masks so that you can restrict the adjustment to only the unmasked areas.

Figure 2.17
Adjustment layers automatically include layer masks.

You can create five different kinds of masks: pixel masks, vector masks, quick masks, clipping masks, and clipping paths. Whichever kind of mask you use, remember that black hides and white reveals—that is, areas in black are protected and white areas are affected. Grayscale areas partially hide, depending on the gray levels.

The Masks panel lets you quickly create a pixel mask or a vector mask, and gives you controls for refining existing masks as well. To open the Masks panel, choose Window > Masks.

Figure 2.18

Create and fine-tune masks in the Masks panel.

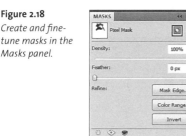

Returning to the Past

Some experiments don't turn out quite as you hoped. After all, if you knew exactly how they'd work, they wouldn't be experiments. So it's nice to know that you can back up and revisit decisions you've made, returning to an earlier stage of the project.

Photoshop includes an Undo command, but that command stores only a single step. Pressing Ctrl+Z (Windows) or Command+Z (Mac OS) undoes the last thing you did. Press it again, though, and you'll redo the step.

You *can* undo additional steps one at a time by choosing Edit > Step Backward (Alt+Ctrl+Z in Windows or Option+Command+Z in Mac OS),

but that could get a bit tedious if you're rethinking a complete editing strategy.

If you want to move backward through time efficiently, make friends with the History panel. You can quickly return to an earlier point in the project, and if you second-guess yourself, you can restore the steps you've taken since that point.

Choose Window > History to open the History panel. The panel lists the steps you've taken—the 20 most recent steps, recorded from the moment you opened the file.

Figure 2.19 *The History panel records the steps you've taken.*

Figure 2.20 *Click a different step to return to an earlier point in the project.*

To go back in time, click the step you want to return to. Everything after that point is dimmed but remembered. Now, if you perform another step, all the dimmed steps are erased and the history resumes with your new direction. But if you change your mind before you perform another step, you can recall the dimmed steps—simply click the bottom step. Or you can click any step in between to move to that point.

tip Keeping track of your steps takes memory, so, by default, Photoshop stores only 20 steps at a time in the History panel. If you want to increase that number (or decrease it), you can change the preferences. Choose Edit > Preferences > Performance (Windows) or Photoshop > Preferences > Performance (Mac OS), and change the History States value in the History & Cache area of the dialog box.

Recommended Workflows

There is no set workflow in Photoshop, or it would just be a giant image-editing wizard. How you go about editing an image depends on the size and quality of the image you start with, what you want to do with it, and the effect you're looking for. Sometimes, you'll just dash into Photoshop or Camera Raw to make a quick change. However, when you're working on more complex images, following some general guidelines can help you achieve the results you want more efficiently and without having to repeat steps unnecessarily.

1. Set the white balance. Especially if you're working with a raw image, start here, and do it in Camera Raw.

2. Crop and straighten the image, if it needs it. Cropping the area early reduces the number of pixels Photoshop fusses with, so you'll work more quickly. More important, it ensures that Photoshop isn't analyzing irrelevant data when you adjust tone and color.

3. Retouch if necessary. Correct any rips in scanned images or odd blotches.

4. Make tonal adjustments and remove color casts. Now that irrelevant colors and tone variations, such as those in cropped areas or in rips and large blemishes, have been removed, make adjustments to the overall tone of the image.

5. Enhance the image. This category is very broad. It includes adding filters and effects, replacing individual colors, transforming areas, combining images, and almost everything else you might want to do.

6. Sharpen the image. Sharpening is typically one of the tasks you should perform last. How much you sharpen an image depends on whether you're publishing it online, printing it to a desktop printer, or sending it out to be professionally printed.

3

Common Tasks

Depending on the image and your goals, you may be able to achieve the look you want with just a few steps. For example, cropping an image to give greater focus to the subject of the picture is a very simple process. So is removing red-eye, or converting an image to black and white. The tasks in this chapter are things that anyone can accomplish quickly in Photoshop.

Cropping an Image

Suppose you need to prepare an image for a picture frame that has different proportions from the original photo. Or perhaps you want to remove distracting background activity to direct the viewer's focus to the main subject of your image. Cropping can help you achieve either of these goals and many others as well.

Cropping doesn't resize the image—it removes part of the image. Using the Crop tool in Photoshop, you can crop an image into any rectangular shape—but only rectangular shapes. You can predetermine the crop size by entering values for height, width, and resolution in the options bar. Or leave those fields blank and drag the Crop bar to any size you want.

Figure 3.1
Drag a crop area.

Figure 3.2
When you press Enter or Return, all that remains is the area inside the crop border.

Figure 3.3 *You can be very specific about the size of the cropped image by entering values in the options bar.*

To crop an image:

1. Choose File > Save As, and name the copy of the image. Preserve your original so you can return to the uncropped image later.

2. Select the Crop tool in the Tools panel.

3. If you need to crop the image to a particular size, enter the values in the Width, Height, and Resolution fields in the options bar.

4. Drag the Crop tool across the image. If you've set a size in the options bar, the crop boundary will go no farther than the size you set (though you can still create a smaller crop). If you left the fields in the options bar blank, you can drag the crop boundary up to the full size of the image.

 The area that is cropped out is dimmed; the area that will remain is bright.

5. If you want to resize the cropped area, drag one of the crop boundary handles. To reposition the boundary, drag from the middle or press an arrow key.

6. When you're satisfied with the crop, click the Commit button in the options bar or press Enter or Return.

Cropping irregular shapes

To crop an image into a shape that isn't a rectangle, use a clipping mask:

1. Select the shape you want to keep, using any of the selection tools.

2. Choose Select > Inverse to select everything but the shape you drew.

3. Choose Edit > Cut to remove everything outside the shape you drew.

4. Choose Image > Trim to reduce the area that is white or transparent around the shape.

If the content is on a background layer, click the layer and rename it to convert it to a normal layer, so you can make the background transparent, if you like. (See Chapter 8 to learn about replacing the background of an object.)

Straightening an Image

If you held your camera crooked, or the picture slipped in the scanner, or you were trying for an artistic effect that didn't work out as you planned, your photo may have angles that aren't quite right. Use the Ruler tool 🔲 to straighten the image in Photoshop.

To straighten an image:

1. Choose File > Save As, and name the duplicate image.

 Work in a copy of the image so you can return to the original if you need to make adjustments.

2. Select the Ruler tool, which is hidden beneath the Eyedropper tool.

3. Identify a horizon line that should be parallel to the top of the photograph. For example, if you're straightening a photo of a house, find a line in the house that is parallel to the ground. You could use a road, or the top of a car, or anything else that is parallel to the edge you want to create. In fact, you don't *have* to use a line that exists in the image, but you do need to figure out what the proper perspective should be.

4. Click the left edge of the line you've chosen, and drag the Ruler tool to the other end. Then release the mouse.

5. Click the Straighten button in the options bar to straighten the image.

Figure 3.4
Drag the Ruler tool along the line you want to use to define the horizontal edge.

Figure 3.5
Photoshop rotates and crops the image to match the angle you drew.

You can undo the straightening and try again, if you aren't satisfied with the results. Note that in the History panel, straightening is listed as two steps, Rotate Canvas and Crop, because part of the image is removed in the process.

tip You aren't limited to straightening a crooked image along an expected horizon. You can also use this feature to create interesting angles for a photograph, shifting perspective and focus.

Resizing an Image

A digital image contains a fixed amount of original image data—once the picture has been taken, that's the data you have to work with. But it doesn't have a fixed size or resolution.

To see the current dimensions and resolution of an image, choose Image > Image Size. The Image Size dialog box displays the dimensions in both pixels and inches (or another measurement unit, if you prefer). To change the size of the image, focus on the information in the Document Size area of the dialog box.

Figure 3.6

Keep an eye on the resolution as you adjust the dimensions of an image.

By default, the Resample Image option is selected in the Image Size dialog box. Resampling is the way Photoshop compensates for missing data when you scale an image up but want to keep it the same

resolution. Photoshop also resamples as it removes data when you scale an image down. Resampling an image changes the number of pixels that are actually in the image. You may be satisfied with the results when you resample an image that you're publishing to the Web; in fact, it may be necessary to resample an image to reduce its size before uploading it. However, if you want a high-quality print of the image, you're usually better off *not* resampling.

To keep the original pixels intact, deselect Resample Image. If Photoshop can't resample, the pixel dimensions are locked and the physical dimensions are tied to the image resolution. That is, if you increase the resolution of the file, the document size is reduced, and vice versa.

To change the image dimensions, enter new values for the width and height. By default, the width and height are linked to keep the image proportional. If you decrease the width by 20 percent, the height will also decrease by 20 percent. If you want to resize the width and height separately, deselect Constrain Proportions.

 Save a copy of the image before you change its size so you can return to the original size later, if necessary.

Enlarging the Canvas

The canvas is the image area. In many cases, the photo you're working with fills the canvas. But you may want to enlarge the canvas to add a border or to extend a background color.

There are a few simple ways to extend the canvas. You can use the Crop tool or the appropriately named Canvas Size dialog box.

To extend the canvas using the Crop tool:

1. Select the Crop tool in the Tools panel.

2. Drag the Crop tool to include the entire image in the cropping area.

3. Drag the crop boundary using its handles to pull it beyond the image.

4. Press Enter or Return to apply the crop. Additional area in the background color appears where you extended the canvas. (If there is no background layer, the extension is transparent.)

Figure 3.7
One way to extend the canvas is to drag a crop border beyond the existing canvas.

To specify the canvas size:

1. Choose Image > Canvas Size.

2. Enter new values for the canvas in the Width and Height fields.

3. Select the anchor point. By default, the middle anchor point is selected, and Photoshop will add canvas evenly around all the edges to meet the dimensions you enter. If you click the left-center anchor point, Photoshop adds canvas only to the top, right, and bottom of the image.

 This concept can be a little tricky, so remember that you can undo the change to the canvas size if you get results you didn't expect.

4. Choose a color for the canvas extension. You can extend the fore-
ground or background color (whatever is currently selected in the
Tools panel); add white, gray, or black; or choose Other to select a
color in the color picker.

5. Click OK to apply the change.

A quick way to add a border to an image is simply to extend the canvas
size and select the border color for the canvas color.

Figure 3.8
*Enter values
in the Canvas
Size dialog box
to extend the
canvas a specific
amount.*

Canvas Size	
Current Size: 1.47M	OK
Width: 9 inches	Cancel
Height: 11 inches	
New Size: 1.47M	
Width: 9 inches	
Height: 11 inches	
☐ Relative	
Anchor:	
Canvas extension color: Black	

Figure 3.9
*To add a border,
extend the
canvas in the
border color.*

tip If you're not sure what the final dimensions should be, but you know how much extra canvas you need on each side, click Relative, and then enter the amount you want to add in the Width and Height fields. If you want to remove canvas (which will also remove image), enter a negative number.

Transforming Layers

You can scale, rotate, skew, distort, flip, or warp a layer, as long as it's not the background layer.

tip To change a background layer to a regular layer, double-click it in the Layers panel. Give it a new name in the New Layer dialog box, and click OK.

To transform a layer:

1. Select the layer in the Layers panel.

2. Choose Edit > Transform > [the transformation you want to apply]. Layer handles appear and the cursor changes to represent the transformation.

3. Drag the layer handles to a new position or enter values in the options bar.

4. Click the Commit button in the options bar to accept the changes (or press Enter or Return).

tip Some of the Transform commands take effect automatically. The Flip Horizontal and Flip Vertical commands are particularly handy for creating symmetrical designs quickly.

To make more than one transformation at a time:

1. Select the layer in the Layers panel.

2. Choose Edit > Free Transform.

3. Drag the layer handles to a new position. As you move your cursor, it changes to represent different transformations. When the cursor is a curved double arrow, drag to rotate the layer. When it's a double-pointed arrow, drag to scale the layer.

4. To warp or distort the layer, click the Switch between Free Transform and Warp Modes button in the options bar. (It looks like a diamond ring.) Then drag handles to distort the image, which appears with a grid over it.

5. Click the Commit button in the options bar (or press Enter or Return) to accept the changes.

Figure 3.10
Scaling a layer with the free-transform handles.

Figure 3.11
Rotating a layer with the free-transform handles.

Figure 3.12
Warping a layer.

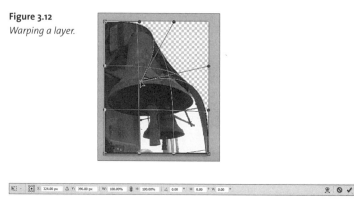

Figure 3.13 *Commit or cancel a transformation, or switch to warp mode in the options bar.*

Removing Red-Eye

Red-eye is the all-too-common effect that gives the subject of a photo a demonic look. Don't worry—the camera hasn't captured your Aunt Sally's secret personality, just the reflection of her retina. Usually, red-eye occurs when you take a photo of people in a dark room, because their irises are wide open. When a retina is reflected by the camera's flash, it appears red.

It's easy to fix red-eye in Photoshop. In fact, there's a tool designed just for this task. Here's how to do it:

1. Zoom into the eye area so you can see it clearly.

2. Select the Red Eye tool [+], which is hidden under the Spot Healing Brush tool.

3. Adjust the settings in the options bar if you need to. Often, the default settings work just fine, but if you know your subject has light-colored eyes, you may want to reduce the Darken Amount.

4. Click the red area in the eye.

That's really all there is to it. You can adjust the Pupil Size and Darken Amount settings to see how the results differ, but for most images, the default settings do the trick.

Lightening or Darkening an Image

There are probably dozens of ways to change how light or dark an image is in Photoshop. The more sophisticated methods are covered in Chapter 4, which deals with more extensive image corrections. However, there are some quick and easy ways to lighten or darken an image in Photoshop. You can use a Brightness/Contrast adjustment layer, a Hue/Saturation adjustment layer, or both.

Adding a Brightness/Contrast adjustment layer:

1. If the Adjustments panel isn't open, choose Window > Adjustments.

2. Click the Brightness/Contrast icon to create a new adjustment layer.

3. Move the Brightness slider to the right to lighten an image or to the left to darken it.

4. Adjust the Contrast slider.

Figure 3.14
Before applying the adjustment layer.

Figure 3.15
*After brightening
the layer.*

Figure 3.16
*Use a Brightness/
Contrast
adjustment layer
to lighten or
darken an image.*

Adding a Hue/Saturation adjustment layer:

1. If the Adjustments panel isn't open, choose Window > Adjustments.

2. Click the Hue/Saturation icon to create a new adjustment layer.

3. Move the Lightness slider to the right to lighten the image or to the left to darken it.

4. Move the Saturation slider to the right to increase saturation or to the left to decrease it.

Converting to Black and White

Converting a color image to black and white (and shades of gray) seems like a straightforward task—and there are simple ways to do it. But there are also countless variations in the way Photoshop can make the conversion, so the best way to perform the task depends on your ultimate goal.

Changing the image mode

You can simply change the image mode if you need to convert the image quickly and aren't too particular about how Photoshop does it. To change the image mode, choose Image > Mode > Grayscale. Then decide whether to flatten layers when prompted, and click Discard when prompted to discard all color information.

Using an adjustment layer

A Black & White adjustment layer gives you much more control in the conversion.

To use an adjustment layer:

1. If the Adjustments panel isn't open, choose Window > Adjustments.

2. Click the Black & White icon to create a new adjustment layer.

3. Move the sliders for the different channels to change their saturation levels. Even though the color itself is gone from the image, the channels remain and they "remember" which areas of the image were originally which color. Their saturation levels affect the grays dramatically.

4. If you want to achieve a specific effect, select an option from the pop-up menu in the Adjustments panel. For example, you can choose Darker, Infrared, or Maximum White for very different results.

5. If you want to add a tint, select Tint in the Adjustments panel, and then click the color swatch to select a color in the Color Picker. This is an easy way to get a sepia-tone effect.

Figure 3.17
Start with a color image.

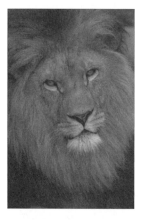

Figure 3.18
Apply a Black & White adjustment layer.

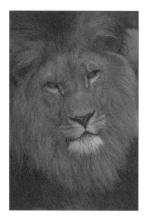

Figure 3.19
Try different settings, such as Infrared.

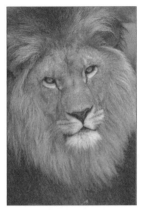

Figure 3.20
You can tweak the way an image is converted to grayscale using a Black & White adjustment layer.

4

Making Corrections

Even carefully planned and posed photographs can have flaws. Photos you snap on the spur of the moment are even more likely to include distracting background objects or to have less-than-ideal lighting. The good news is that you can improve—and sometimes even perfect—exposure and lighting. You can also often remove unwanted objects, such as phone lines or even people, in Photoshop.

Unless you're working with an adjustment layer, most image corrections involve changing the actual pixels. So, once again, it's a good idea to be working in a copy of the image, leaving your original intact for future use.

Tonal Changes

The tonality of an image includes qualities of lightness, darkness, and contrast. Photoshop includes a full range of tools to correct or enhance the tonality of an image. Some of the tools are fairly straightforward, while others are a bit more complex. They all work essentially the same way, however: they map the original pixel values to a new range of values.

If you're working on an image that you expect to print professionally or for some other reason the image tone is absolutely critical, make sure you've calibrated your monitor and you're using the appropriate color management profile. (For help calibrating your monitor, see Photoshop Help.) Additionally, make changes in the color mode you'll be using for the final output. If the image is intended for the Web, work in RGB mode. If you plan to print the image professionally, either work in CMYK mode or convert to CMYK just before you print. But don't move back and forth between the modes if you can avoid it.

tip Russell Brown, renowned and entertaining Photoshop guru, can help you calibrate your monitor. Visit http://tv.adobe.com/watch/dr-browns-photoshop-laboratory/printing-experiments to see him in action.

Generally, the following workflow will get you to good results most efficiently:

1. Remove flaws such as dust spots or scratches before making color and tonal adjustments.

2. View the histogram for the image to see its quality and tonal range.

3. Start by adjusting the color balance to remove any color casts or correct saturation.

4. Adjust the tonal range using either a Levels or Curves adjustment layer. There, you'll set the white point (defining highlights) and black point (defining shadows), and make any necessary adjustments to the midtones.

5. Finally, make any other color adjustments, such as hue, saturation, or vibrance.

To open the Histogram panel, choose Window > Histogram. The Levels dialog box also displays a histogram.

A histogram shows you how pixels are distributed in an image, so you can see how much detail appears in the shadows (on the left), the high-lights (on the right), and the midtones (in the middle). Much of the time, you'll want an even distribution—an image that is neither too dark nor too light. However, in some cases, it's appropriate for the detail to be concentrated in the shadows or the highlights, depending on the mood you want to convey.

Figure 4.1

The histogram shows how pixels are distributed. In the first image, there's more detail in the highlights and midtones. The second image has more detail in the shadows, with some in the highlights.

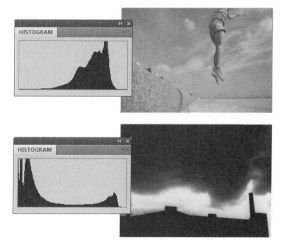

You can perform a generalized color correction using a Color Balance adjustment layer, or you can let Photoshop take a stab at it by using the Auto Color option in the Levels or Curves dialog box. Balancing color removes any color cast, such as a blue or red cast, that may appear in your image.

To add a Color Balance adjustment layer:

1. Click the Color Balance icon in the Adjustments panel.

note The Color Balance adjustment works only with the composite channel, which includes the entire image. If you've been working with an individual channel, make sure the composite channel is selected in the Channels panel.

2. Select Shadows, Midtones, or Highlights as an area where you want to focus the changes.

3. Drag the sliders toward the colors you want to increase and away from the colors you want to decrease. For example, if the image has a red cast, drag the slider away from Red and toward Cyan. Be careful not to overcorrect—you can easily *add* a color cast using the Color Balance adjustment!

To remove a color cast using the Auto Color option:

1. Click the Levels or Curves icon in the Adjustments panel.

2. Click Auto.

The Auto option neutralizes midtones and clips shadows and highlight pixels.

Figure 4.2

Use a Color Balance adjustment layer to remove color casts or otherwise adjust color.

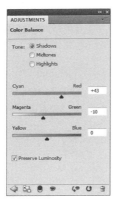

Levels

The Levels panel affects the levels of intensity of shadows, midtones, and highlights. It's not all that hard to make the adjustments. The histogram helps you see where the detail is in the image, and there are some rules of thumb for improving it.

In the Levels histogram, the left side represents the shadows, the right side represents the highlights, and the center shows the midtones. The input and output sliders are related, but here's what you need to know to use this adjustment: The left input slider, at the bottom of the histogram, sets the image's black point—the point beyond which all data is seen as pure black. The right input slider sets the white point—the point beyond which everything is treated as pure white. Generally, you'll get better results if you move the left slider to the point where significant shadow data occurs, and the right slider to the point where significant highlight data begins.

The middle slider adjusts the gamma, which changes the intensity of the middle range of gray tones without making large changes to highlights and shadows.

You'll hear photo-editing pros talk about clipping shadows or highlights, something you typically want to avoid. When shadows or highlights are clipped, the pixels are a solid white or black and provide no detail.

Figure 4.3

Adjusting levels can be a quick way to punch up the intensity of the color in your image, and to ensure you're seeing the appropriate detail.

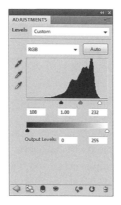

To apply a Levels adjustment:

1. Click the Levels icon in the Adjustments panel.

2. Drag the black and white input levels sliders to the edge of the first group of pixels at either end of the histogram. Photoshop sets the black and white points at the new position—everything to the left of the black point is solid black; everything to the right of the white point is solid white.

 To see which areas in an image are being clipped, hold down Alt or Option as you drag the black point and white point sliders.

3. Adjust the middle slider to tweak the midtones. Moving it to the left lightens the image; moving it to the right darkens the image.

To neutralize a color cast using the Levels adjustment:

1. Click the Levels icon in the Adjustments panel.

2. Click the Set Gray Point Eyedropper tool.

3. Click in a part of the image that should be neutral gray.

Curves

The Curves adjustment has nothing to do with the bodaciousness of your subject. You use the Curves adjustment to make more gradual changes throughout the tonal range than you can through the Levels adjustment (which has only three points of adjustment: black, white, and gamma). Why curves? Because the adjustments appear on a graph, and as you adjust the tonal range, you're adjusting the curve of the line.

The horizontal axis of the graph represents the input values; the vertical axis represents the output values. Initially, the tonal range is represented as a straight diagonal baseline because the input and output values are identical. By default, the Curves graph shows the amount of light, so moving the curve upward lightens the image and moving it downward darkens the image. The steeper sections of the curve represent areas of higher contrast, and flatter sections represent lower contrast. Moving a point in the top portion of the curve adjusts the highlights; moving a point in the center adjusts the midtones; and moving a point in the bottom section adjusts the shadows. You generally need to make only small curve adjustments to correct the tone and color in an image.

note **You can display ink percentage instead of the amount of light. Choose Curve Display Options from the Adjustments panel menu, and select Pigment/Ink %.**

Figure 4.4

Adjust the curves to make more gradual changes through the tonal range.

 tip Photoshop shows you the baseline as a reference as you make changes. If that line distracts you, deselect Show Baseline in the Curve Display Options.

To adjust curves:

1. Click the Curves icon in the Adjustments panel.

2. Add a point on the curve by clicking directly on it. You can add up to 14 points to a curve.

3. Use the black point and white point sliders to set the black and white points. Typically, you want the black point to be at the point that the shadow data appears, and the white point to be at the point that the highlight data appears.

4. Click a point, and drag the curve until you're satisfied with the tone and color of the image. Or, enter new values for the point in the Output and Input boxes.

You can also select the On-image adjustment tool, and then click the area in the image you want to adjust. Drag the point up or down to lighten or darken the values for all similar tones in the image.

 tip To see how an adjustment layer has affected the image, click its eye icon to hide it in the Layers panel. Click the eye icon again to show it.

Vibrance

The Vibrance adjustment saturates the colors that need it while leaving the colors that are already saturated alone. It's particularly useful if you're working with an image that contains skin tones, as it keeps them from becoming oversaturated.

1. Click the Vibrance icon in the Adjustments panel.

2. Drag the Vibrance slider to increase or decrease color saturation.

3. To apply the same amount of saturation adjustment to all colors (even those that are already saturated), move the Saturation slider.

Figure 4.5
Adjust the Vibrance slider to intensify some colors without oversaturating others.

Correcting shadows and highlights

If an image was taken with strong backlighting, resulting in silhouettes—or if the subject of the image was too close to the flash and ended up kind of washed out, the Shadows/Highlights command may be your best bet for correction. The Shadows/Highlights command doesn't just lighten or darken an image; instead, it lightens or darkens each pixel based on nearby pixels in shadows or highlights. You can make adjustments to shadows and highlights separately. The defaults are set to fix images with back-lighting problems.

To adjust image shadows and highlights:

1. Choose Image > Adjustments > Shadows/Highlights.

> **note** There is no way to create an adjustment layer for this adjustment, so using it will change the actual pixels in your original image. Remember to create a copy of the image before making this kind of correction! You can also duplicate the background layer (or any other layer you want to affect), and then apply the adjustment to the layer copy, leaving the original unaffected—or you could apply it to a Smart Object.

2. Move the Amount slider or enter a percentage in the Shadows or Highlights box. Larger values lighten shadows more or darken high-lights more.

3. Click OK when you're happy with the adjustment, or select Show More Options and make fine-tuned adjustments.

Selecting a variation

If you're overwhelmed by tone correction options, or if you're not sure what might make a particular image look better, try the Variations command. The Variations dialog box shows you alternatives that present different color balance, contrast, and saturation settings, so you can select the one that achieves the look you want.

Figure 4.6

Correct lighting issues using the Shadows/ Highlights adjustment; select Show More Options to tweak the settings further.

Shadows/Highlights

Shadows
Amount: 9 %
Tonal Width: 50 %
Radius: 30 px

Highlights
Amount: 37 %
Tonal Width: 65 %
Radius: 30 px

Adjustments
Color Correction: -5
Midtone Contrast: +9
Black Clip: 0.01 %
White Clip: 0.01 %

Save As Defaults
☑ Show More Options

OK
Cancel
Load...
Save...
☑ Preview

 note The Variations plug-in is a 32-bit plug-in, and it isn't available when you run Photoshop in 64-bit mode on the Mac. To start Photoshop in 32-bit mode, select the Photoshop application in the Finder, choose File > Get Info, and select Open In 32-bit Mode. Then, start the application again.

1. Choose Image > Adjustments > Variations.

 The Variations dialog box shows two thumbnails at the top of the dialog box: the original settings and the current selection. The current selection thumbnail changes as you make choices.

2. Select what to adjust in the image. You can adjust shadows, midtones, or highlights, as well as saturation.

3. Drag the Fine/Coarse slider to change the amount of each adjustment. (Each tick doubles the adjustment amount.)

4. Adjust the color and brightness:

 ▪ To add a color, click the appropriate thumbnail.

 ▪ To subtract a color, click the thumbnail for its opposite color.

- To adjust brightness, click a thumbnail on the right side of the dialog box.

note The effects of clicking the thumbnails are cumulative.

Figure 4.7
Visual types, take heart. You can see the effects of different color and contrast options in the Variations dialog box.

Healing Blemishes

There's no need to break out the pimple cream when you have Photoshop to work with. Several tools in Photoshop actually "heal" an area of the image, based on the surrounding content. There's some magic involved, but also some skill. Different blemishes—whether they be flaws in skin, rips in photos, thumbprints on camera lenses, or nosy passersby—can best be healed using different tools or approaches.

First, you want to consider the size of the blemish. Small spots may be improved with a quick click of the Spot Healing Brush tool. Larger areas are better candidates for the Healing Brush, Patch, or Clone Stamp tools. Where the background is fairly consistent, content-aware fill is an impressive and efficient solution.

The Spot Healing Brush, Healing Brush, and Patch tools are all grouped together in the Tools panel.

Spot Healing Brush tool

Appropriately enough, the Spot Healing Brush tool looks like a bandage with a spot behind it.

To use the Spot Healing Brush tool:

1. Select the Spot Healing Brush tool in the Tools panel.

2. Set up the brush size and attributes in the options bar. Select a brush size that covers the area you want to repair, but isn't much larger than it.

3. Select Proximity Match, Create Texture, or Content-Aware in the options bar. Use Proximity Match when the surrounding area is consistent; Content-Aware is a better choice if you're repairing areas in a pattern.

4. Click on the blemish, or click and drag to repair a larger area.

The Spot Healing Brush tool replaces the pixels you paint with pixels that are similar to the surrounding area. If you're repairing a blemish on a stripe or obvious pattern, select Content-Aware in the options bar to avoid distracting pattern shifts. The Proximity Match option is ideal where the surrounding area is similar, such as when you want to cover

the smudge on a wall. It can be useful as well on small and complex patterns, where shifts in the pattern won't be noticed.

Figure 4.8
Before, there was a white streak near the column.

Figure 4.9
As you drag the Spot Healing Brush tool, the area you cover appears dark.

Figure 4.10
The white streak is healed to blend with the blue sky.

Content-aware fill

There is no content-aware fill tool, but filling a selection with the Content-Aware setting is a powerful way to remove unwanted objects or repair blemishes.

Need to remove a car from an otherwise empty road? Or remove a time stamp from a photo? Content-aware fill is the ticket, especially when the area surrounding the object or blemish you're removing changes. Note, however, that you may not get the best results if the surrounding area includes obvious patterns or stripes.

To apply content-aware fill:

1. Select the area you want to replace.

2. Choose Edit > Fill.

3. In the Fill dialog box, choose Content-Aware from the Use menu.

4. Select a blending mode and opacity if you want to moderate the effect.

5. Click OK.

Figure 4.11
Select the area you want to replace.

Figure 4.12
Choose Content-Aware in the Fill dialog box.

Healing Brush tool

The Healing Brush tool is represented by a bandage. It works similarly to the Spot Healing Brush tool in that it replaces the selected pixels with an approximation of the surrounding area. It also matches the texture, lighting, transparency, and shading of the sampled area to the area you're retouching, so the healed area blends into the area around it. Unlike the Spot Healing Brush tool, however, you identify the area to sample. (You can also choose to fill the area with a pattern, but that's really only useful for most images if you've already created a custom pattern.) The Healing Brush tool is a good tool to use if you need to retouch a larger area or need more control over the repair.

To use the Healing Brush tool:

1. Select the Healing Brush tool in the Tools panel.

2. Select a brush size and attributes in the options bar.

3. Select Sampled in the options bar.

4. Select Aligned if you want to continue sampling from the place you left off each time you release the mouse and click again. Deselect Aligned if you want to start over from the sample point each time you release the mouse.

5. Choose which layers to sample from, if your image has multiple layers.

6. Set the sampling point: with the pointer over the area you want to sample, Alt-click (Windows) or Option-click (Mac OS).

7. Paint over the area you want to retouch.

Figure 4.13
The lens was smudged, leaving an unattractive area in the middle of these flowers.

Figure 4.14
Photoshop blends the sampled area with the edges of the area you paint, so the smudge is gone.

One of the things that makes the Healing Brush tool so versatile is that you can sample from one image and use the sample pixels to heal another. You can get creative with this and use it as a background replacement method, or use it the more traditional way: to repair a texture in one photo with the similar, unblemished area of another.

The trickiest part of this tool is understanding the Aligned option, which works the same way for the Clone Stamp tool.

Say you've clicked a sampling point at the very upper-left corner of the image. When you start painting with the Healing Brush, it starts painting

with the pixels in that corner, and moves out from the corner as you paint, continuing to pick up pixels in relation to the original sampling point. That part is true regardless of whether Aligned is selected. Then you release the mouse.

Now, what happens when you start painting again depends on whether Aligned is selected: If it is *not* selected, wherever you start painting again starts over with the sampling point. If Aligned *is* selected, wherever you start painting again begins in relation to where you were painting before, as if you'd never released your mouse. This can make a huge difference, especially if you're painting over something such as a brick wall, where you want to align the bricks carefully.

Patch tool

The Patch tool copies pixels from one area to another, using a selection, and then uses those pixels as the basis for healing the area. You can either select the pixels you want to use or the pixels you want to replace: select Source in the options bar to select the pixels you want to replace or select Destination in the options bar to select the pixels you want to use.

To use the Patch tool:

1. Select the Patch tool.

2. Select Source or Destination in the options bar.

3. If you selected Source, drag the tool to select the pixels you want to replace; if you selected Destination, select the pixels you want to use in the repair.

4. Drag the selection either onto the pixels you want to use for the repair (Source) or onto the pixels you want to patch (Destination).

Figure 4.15
Select the area with the Patch tool.

Figure 4.16
Drag the election to the area you want to use as a patch.

Figure 4.17
Photoshop makes the repair.

Clone Stamp tool

You can also clone any part of an image, exactly copying the pixels to replace others. Not only can you repair blemishes this way, but it's a great way to duplicate areas of the image. For example, you can add a window to a house or turn one mailbox into two using the Clone Stamp tool .

Like the Healing Brush tool, the Clone Stamp tool requires that you set a sampling point from which to start copying the pixels. Select Aligned to continue painting from your original starting point; deselect it to start over with the sampling point every time you begin a new stroke.

To use the Clone Stamp tool:

1. Select the Clone Stamp tool in the Tools panel.

2. Set the brush size and attributes, and select the blending mode and opacity levels in the options bar.

3. Select or deselect Aligned, and choose which layers you want to sample from.

4. Alt-click or Option-click the area you want to use as source pixels to create a sampling point.

5. Paint over the area you want to replace with the cloned pixels.

The Clone Source panel

The Clone Source panel gives you a little more control over efforts with the Clone Stamp or Healing Brush tools. The most useful aspect of the Clone Source panel is the ability to view an overlay of the sample source so you can preview the pixels before you apply them. The Preview option is selected by default, so you can benefit from it even without ever opening the Clone Source panel.

Figure 4.18
*With Photoshop,
cloning people
is legal.*

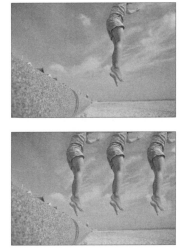

One cool feature of the Clone Source panel is that you can scale or rotate the sample source to match the size and orientation of the area you want to replace. You can also set up to five different sample sources and select the one you want without having to resample each time.

To open the Clone Source panel, choose Window > Clone Source.

Figure 4.19
*Use the Clone
Source panel to
customize the
way you sample
pixels for cloning
or healing areas.*

Erasing Pixels

If you want to remove pixels altogether—instead of replacing them with similar pixels—the Eraser tool might be your friend. I say it *might* be your friend because, in general, the Eraser tool is not the most graceful way to achieve most goals. But it's a good tool to have on backup in your toolbox.

The Eraser tool appears to erase content, but it's not actually erasing anything. If you're working on a background layer or a layer with transparency locked, it replaces the pixels with the current background color. Otherwise, it replaces the pixels with transparency.

Probably the neatest way to use this tool is to use it when you want to restore the image to its previous state. Select Erase to History in the options bar—and the Eraser tool will do just that. It's handy if you aren't so keen on a change you made, or if you want to keep the change but have it affect a smaller area of the image.

tip To erase back to a particular state, click the left column of the state in the History panel before erasing.

Figure 4.20 *Select Erase to History in the options bar to erase part of the image to an earlier state.*

One unusual thing about the Eraser tool is that you can change the shape of the tool to act as a brush, a block, or a pencil by selecting the mode in the options bar.

The Eraser tool has a cool friend, the Magic Eraser tool. It erases pixels of a similar color, replacing them with transparency. (If you're working on a background layer, it's converted to a regular layer and the pixels are

replaced with transparency.) Select the tool, click on the color you want to erase, and *voilà!* You can erase only contiguous pixels, or all pixels of that color; to erase all pixels of that color, deselect Contiguous in the options bar. The Tolerance setting determines how similar in color pixels need to be in order to be erased. The greater the tolerance value, the wider the range of colors that will be replaced with transparency.

> **tip** It's called the Magic Eraser tool because it selects which pixels to erase based on their color, just as the Magic Wand tool selects pixels based on color.

Figure 4.21
Click once with the Magic Eraser tool to remove pixels of a particular color. Click again to erase pixels of a different color.

The Background Eraser tool erases the background so you can replace it or otherwise work with foreground objects separately. This and other background-replacement techniques are covered in Chapter 8.

Replacing Colors

Change your hair color, or the color of the sky, or anything else you like using the Color Replacement tool ![icon] in Photoshop. You sample a pixel to identify the color you want to replace, and then paint with a new foreground color. The Color Replacement tool paints only the pixels that match the sampled color.

To replace a color:

1. Select the Color Replacement tool, which is grouped with the Brush tool.

2. Select a brush size and attributes in the options bar. Leave the Blending Mode set to Color.

3. Select a Sampling option.
 - **Once** selects a single color, wherever you first click.
 - **Continuous** samples colors as you drag, so that you can change different shades as well.
 - **Background Swatch** replaces areas that contain the current background color, regardless of where you first click. (You can use the eyedropper to sample a color for the background color.)

4. Select a Limits option.
 - **Discontiguous** replaces sampled color wherever you paint.
 - **Contiguous** replaces colors that are contiguous with the color immediately under the pointer.
 - **Find Edges** replaces connected areas and attempts to retain sharper edges.

5. Adjust the tolerance. The higher the tolerance, the wider the range of colors that will be replaced. Use a very low tolerance if the color you want to replace is similar to the background color.

6. Click the foreground swatch in the Tools panel, and select the replacement color in the Color Picker.

7. Click the color you want to replace, and then drag to paint over the unwanted color. Be careful painting around the edges. If the background color is similar to the color you're replacing, the Color Replacement tool may have trouble finding the edges.

tip I find I get the best results by selecting Once for the Sampling option and either Contiguous or Discontiguous for the Limits option. Then I adjust the Tolerance value depending on my image.

Figure 4.22
Paint with the Color Replacement tool to change the color of an object.

Reducing Noise

You might think your images are quiet, hanging out as visual entities. But if there are random, extraneous pixels that aren't part of the image detail, they actual contain noise.

Where does noise come from? You can end up with noise in scanned images resulting from a scanning sensor or from a grain pattern in the scanned film. In digital images, noise can occur when you use a high ISO setting on a digital camera, or if the image is underexposed, or if you shoot a picture in darkness with a long shutter speed. You can even get noise if you oversharpen an image.

However it gets there, if it distracts from the story you're trying to tell with your image, you probably want to get rid of it. The good news is that Photoshop includes noise reduction tools. The bad news is that removing noise is tricky and may not always be completely possible.

There are two kinds of noise:

- **Luminance noise** is grayscale data that can make an image look grainy.
- **Color noise** shows up as colored artifacts in your image. Color noise is typically easier to remove than luminance noise.

You can use the noise reduction filter in Photoshop, but the newer filters in Camera Raw usually do a better job. Keep in mind that noise reduction is usually achieved by blurring the image a bit so that the noise blends in with the rest of the image. So, you'll want to restore some detail after you reduce noise. As with many aspects of image editing, the goal is to strike a balance.

To remove noise in Photoshop:

1. Choose Filter > Noise > Reduce Noise.

2. Click the plus button below the preview window to zoom into an area that contains noise, so you can clearly see how it changes as you adjust the settings. You can drag the preview to focus on different areas of the image.

3. Keep an eye on the preview window as you adjust the Strength, Preserve Details, Reduce Color Noise, and Sharpen Details sliders. Strength reduces luminance noise; Reduce Color Noise removes chromatic noise.

4. If you're comfortable working with channels, you can select Advanced, and then click the Per Channel tab to specify luminance noise removal in each channel.

5. Click OK to apply your changes.

Figure 4.23

The Reduce Noise filter is pretty good at removing color noise, but not quite as accurate when it comes to luminance noise.

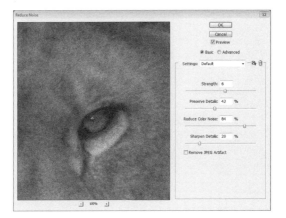

To remove noise in Camera Raw:

1. Open your image in Camera Raw. Remember that Camera Raw can open only TIFF, JPEG, DNG, and raw image formats.

2. In Camera Raw, click the Detail tab.

3. Zoom in to at least 100 percent to preview the changes you're making.

4. Move the Luminance slider to remove luminance noise, and then adjust the Luminance Detail and Luminance Contrast sliders to restore some detail and contrast to the image.

5. Move the Color slider to remove color noise, and then adjust the Color Detail slider as well.

Figure 4.24
If noise is a serious problem in your image, take advantage of the Detail pane in Camera Raw to remove it.

Sharpening Images

Most images can benefit from sharpening, which enhances the edges by increasing the contrast of adjacent pixels. Photoshop includes several filters that sharpen areas of an image. Which filter you use depends on whether you need to sharpen all or only part of an image, and how much control you require. No matter which method you use to sharpen an image, be careful not to oversharpen. Sharpening brings out the detail in images, but it can't compensate for severely blurred images.

Here are some tips for sharpening images:

- Always work with a duplicate of the image, so you can return to the original if you aren't wild about the changes you've made. Additionally, you can convert layers to Smart Objects and then use Smart Filters to sharpen them.

- Create a duplicate layer and apply sharpening to that layer, so you can turn it off if you need to sharpen differently later. If you work with a duplicate layer, use the Luminosity blending mode for the best results.

- Save sharpening for the last step, when you're just about to optimize your image for the Web or prepare to print it. The exception is if you need to sharpen to correct some blur caused by the camera or scanner; that sharpening should occur at the beginning of your workflow.

- The Sharpen, Sharpen Edges, and Sharpen More filters are automatic. The Smart Sharpen and Unsharp Mask filters give you more control.

Smart Sharpen

The Smart Sharpen filter performs multiple tasks at once. In addition to sharpening edges, it reduces noise. You can choose whether to apply the filter to the entire image, its shadows, or its highlights.

You can also choose which algorithm the filter uses to sharpen the image:

- **Gaussian Blur** uses the same algorithm as the Unsharp Mask filter; it increases the contrast along the edges.

- **Lens Blur** detects edges and detail; it sharpens finer detail without adding many halos.

- **Motion Blur** removes blur that was caused by the movement of either the camera or the subject of the photo. If you choose Motion Blur, you also need to specify the angle for the blur.

Figure 4.25
The Smart Sharpen filter gives you control over the way Photoshop sharpens your image.

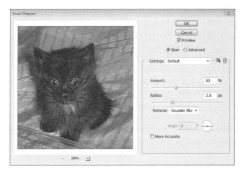

To use the Smart Sharpen filter:

1. Zoom to 100 percent or greater so you'll see an accurate preview of the sharpening.

2. Choose Filter > Sharpen > Smart Sharpen.

3. Select an option from the Remove menu to determine which algorithm is used to sharpen the image.

4. Keep an eye on the preview window as you adjust the Amount and Radius sliders. The Amount slider determines how much sharpening occurs; the higher the amount, the greater the contrast between edge pixels. The Radius slider determines how many pixels surrounding the edge pixels are affected by sharpening.

5. Select More Accurate if you want Photoshop to process the file more slowly, resulting in a more accurate sharpening.

6. If you want to adjust the sharpening of shadows and highlights separately, click the Advanced button to display additional tabs. The settings on the Shadow and Highlight tabs let you reduce halo artifacts.

7. Click OK when you're satisfied with the sharpening.

note You can apply the Smart Sharpen filter to only one layer at a time. If you need to sharpen multiple layers, merge them, convert all the layers into one Smart Object, or flatten the file before sharpening. This is yet another reason to work in a copy of the file—and to sharpen at the end of your workflow.

Unsharp Mask

It sounds like it ought to blur the image, or make it "unsharp," but the Unsharp Mask filter actually sharpens images. Its name comes from a traditional darkroom technique, in which the original blurry negative of

the image was overlaid with an attempt at sharpened edges, and a final print was created from that.

The Unsharp Mask filter removes Gaussian blur by increasing the contrast along the edges: it makes the dark areas darker and the light areas lighter. The filter determines which pixels to darken or lighten based on the pixels near them. The radius determines how large an area the filter compares. If you go too far with sharpening, you'll probably see a halo effect around the edges.

tip **The effect of the Unsharp Mask filter is more obvious on the screen than it is in high-resolution printing. If you'll be printing the image, experiment to find out which settings work best for your final output.**

Figure 4.26
Use the Unsharp Mask filter to sharpen the edges in an image.

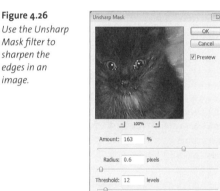

To use the Unsharp Mask filter:

1. Choose Filter > Sharpen > Unsharp Mask.

2. Select the Preview option if it's not already selected. When Preview is selected, you can preview the filter results in the full image window.

Just deselect Preview to compare the sharpened image with the original.

3. Set the Radius value. Unless you're going for a dramatic, artistic effect, keep the radius pretty low, usually between 1 and 2 pixels.

4. Adjust the Amount slider to increase or decrease the contrast. For high-resolution printing, Adobe recommends 150 percent to 200 percent.

5. Set the Threshold value. The threshold determines how different the pixels must be from the surrounding area to be considered edge pixels. The default threshold, 0, sharpens every pixel in the image. For most images, you'll do best with a threshold between 2 and 20.

6. Continue adjusting the sliders until you reach a combination that works for your image, and then click OK to make the change.

 The Unsharp Mask filter can be applied to only one layer at a time, so you might need to merge layers before applying it.

 You can moderate the effect of the Unsharp Mask filter if it oversaturates colors. Choose Edit > Fade Unsharp Mask, and choose Luminosity from the Mode menu.

Correcting Specific Areas

Making corrections to the entire image is often essential. Sometimes, though, only a portion of the image needs to be sharpened or have noise reduced. To correct only a portion of the image, you can use a layer mask.

If you're working with an adjustment layer, a layer mask is built in. To adjust a masked area:

1. Use any selection tool to select the part of the image you want to affect.

2. Select the adjustment icon in the Adjustments panel to create a new adjustment layer. Photoshop creates a mask that protects the unselected area in the layer.

3. Make the adjustments.

Figure 4.27
When you add an adjustment layer, Photoshop automatically creates a layer mask for it.

If you want to apply sharpening or noise reduction to a specific area of the image, first create a new layer.

1. Use a selection tool to select the area you want to affect.

2. If the content includes multiple layers, choose Edit > Copy Merged to copy all the visible content in the selection onto a single layer. (If you're working with only a single layer, you can choose Edit > Copy.)

3. Choose Edit > Paste to create a new layer.

4. Select the new layer and apply the sharpening, noise reduction, or other enhancement.

5

Editing Images in Camera Raw

Adobe Camera Raw is an image-editing application that comes with Photoshop. You can accomplish many of the same editing tasks in Camera Raw, such as cropping, adjusting the tone, and sharpening. The interface is simpler, and in some cases, you may be able to make all the changes you need in Camera Raw, without ever opening Photoshop.

It's called Camera Raw because the utility was designed to work with raw image files, which contain unprocessed picture data from the digital camera's sensor. Not all cameras can capture images in raw format, but most recent digital cameras can. You can open JPEG and TIFF images in Camera Raw as well, but you'll have the most flexibility working with raw images. Adobe frequently offers significant updates for Camera Raw, so if you enjoy working with it, check the Adobe Web site for updates.

Capturing Raw Images

There's a tremendous advantage to working with raw data. When a camera saves an image as a JPEG or a TIFF, it seals in image-processing information, including lighting and tone settings. In a raw file, none of that processing has taken place, so you can work with only the pure image data. It's comparable to working with a negative from traditional film.

To capture a camera raw file, set your digital camera to save files in its own raw file format. Many cameras use proprietary formats, so the file you download may have an unusual file extension, such as NEF (Nikon) or CRW (Canon). Your camera manual or the manufacturer's Web site should tell you how to set your camera to take raw images.

Camera Raw can open and edit a camera raw image file, but it can't *save* an image in a raw format. However, you can save images in DNG (digital negative) format. The changes you make in Camera Raw travel with the image in a sidecar XML file, as metadata, so you can revisit the raw data at any time.

note Unfortunately, the Photoshop Raw format, which uses a RAW extension, has nothing to do with Camera Raw. The Photoshop Raw format is pretty obscure; it's used to transfer images between applications and computer platforms when there aren't other supported formats to use. Mainly it just confuses people, as far as I can tell.

Opening Images in Camera Raw

By default, when you open an image in a camera raw format in Photoshop, it opens in Camera Raw first. However, if you want to open TIFF or JPEG images in Camera Raw, head on over to Bridge to do so.

 If you've already edited a JPEG or TIFF image in Camera Raw, opening it in Photoshop will open Camera Raw first.

To open an image in Camera Raw:

1. Open Bridge.

2. Select the image or images you want to edit. (Images must be in JPEG, TIFF, DNG, or a raw format.)

3. Choose File > Open in Camera Raw.

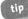 Double-clicking DNG, raw-format files, or images you've already edited in Camera Raw opens Camera Raw. Double-clicking TIFF or JPEG images typically opens Photoshop.

The Camera Raw Work Area

Camera Raw gives you simple but extensive controls for adjusting the white balance, exposure, contrast, and other tonal qualities for your image.

Because it's a utility within Photoshop, Camera Raw has no menu bar, options bar, or application bar. Instead, tools are across the top, editing panes are on the right side, and a link to the image file settings is at the bottom. For the most part, an effective Camera Raw workflow involves moving from the upper-left corner, through the tools, and then across the panes on the right. Start by setting the white balance, cropping the image, and repairing any spots and red-eye; then move on to tonal adjustments and image enhancements.

Figure 5.1

The Camera Raw work area.

A. Filmstrip

B. Toolbar

C. Histogram

D. Image adjustment panes

E. Zoom levels

F. Click to display workflow options

Adjusting White Balance

The white balance of an image reflects the lighting conditions under which it was captured. White balance includes two components:

- **Temperature** determines how warm or cool the image appears.

- **Tint** compensates for any magenta or green color casts.

Your camera records the white balance at the time of exposure; that's the As Shot value in Camera Raw. If the lighting was less than optimal or there was a glare, you may need to adjust the white balance. If you're working with a raw image, you can adjust it dramatically. Even with a JPEG or TIFF image, however, you can improve an image substantially with a simple white balance change.

You can change the white balance using the White Balance tool , or by changing settings in the Basic pane.

To change the white balance using the White Balance tool:

1. Select the White Balance tool from the toolbar.

2. Click an area in the image that should be white or gray. Camera Raw uses the area you sample to determine the color of the light in which the scene was shot and then adjusts every other pixel for that lighting automatically.

3. Click a different area to achieve a different lighting result. Click as many areas as you like until you find the lighting that works for the image.

Figure 5.2
Click the White Balance tool on a neutral area. Camera Raw adjusts the white balance throughout the image.

To change the white balance using the Basic pane:

1. Choose an option from the White Balance menu. If you're working with a raw image, Camera Raw includes options for several different lighting conditions, including clouds or sun. If you're working with a JPEG or TIFF image, you can choose from As Shot, Auto, or Custom.

2. Adjust the Temperature and Tint sliders as necessary. When you adjust the sliders, the White Balance menu switches to Custom.

Figure 5.3
You can tweak the white balance using the sliders at the top of the Basic pane.

Cropping and Straightening Images

The Crop tool crops images in Camera Raw; the Straighten tool crops an image as you straighten, or rotate, it. If you need to crop or straighten an image, do so before you make tonal changes, so that Camera Raw only considers the remaining area of the image in its calculations.

To crop an image:

1. Select the Crop tool.

2. Drag the Crop tool across the area you want to keep.

3. Release the mouse. The area that remains is in full color; the area you cropped out is dimmed.

4. Press Enter or Return to accept the crop.

Unlike cropping in Photoshop, cropping in Camera Raw doesn't make a permanent change to the file. Instead, Camera Raw records the crop the same way it records all the other changes, and you can undo or redo the crop later.

To straighten an image:

1. Select the Straighten tool.

2. Drag the tool along a line you want to use for the image edge.

3. Release the mouse. Camera Raw rotates the image area along that edge, and crops outside the rectangular area it defines.

4. Press Enter or Return to apply the crop.

Figure 5.4
When you crop an image, the part you omit is dimmed.

Figure 5.5
Camera Raw straightens and crops the image at the same time.

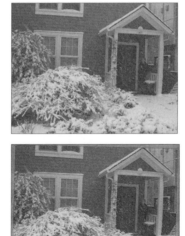

tip If you crop an image in Camera Raw and click Done, the crop informa-
tion is saved with the image, but it's still not permanent. To change
the crop, open the image in Camera Raw again, select the Crop or Straighten
tool, and change the crop.

Removing Isolated Blemishes

You can quickly make unwanted spots, stains, or blemishes disappear
using the Spot Removal tool 🖌 in Camera Raw. The tool is similar to
the Spot Healing Brush tool and content-aware fill in Photoshop, in that
it replaces the selected area with other content.

When you click a problem area, Camera Raw identifies a similar area in
the image to use as a source to replace the pixels. In Heal mode, Camera
Raw copies only the texture area from the source, while Clone mode copies
the color, texture, and tone, creating an exact copy. For most blemishes,
Heal mode gives the best results.

To remove a blemish:

1. Select the Spot Removal tool in the toolbar.

2. In the Spot Removal pane, choose either Heal mode or Clone mode.

3. Adjust the Radius slider so that the radius is larger than the area you
 want to replace.

4. Click on the area you want to replace.

 Camera Raw displays a red dashed line around the area you're replac-
 ing and a green dashed line around the area it's chosen to use as
 source content for the replacement.

 tip Instead of adjusting the Radius slider, you can simply drag over the
area to expand the radius.

5. Drag the green dashed circle to a different area if you're not satisfied with the repair.

6. Adjust the Opacity slider if you want to blend the source pixels with the original pixels.

Figure 5.6
Use the Spot Removal tool to replace areas in an image with pixels from another area.

Adjusting the Overall Tone

The settings on the Basic pane adjust the tonal qualities of an image. You can save some time by clicking Auto to see what Camera Raw does on its own. Sometimes, the changes it makes are spot on, and sometimes they aren't. If they aren't, experiment with the sliders.

The Exposure slider defines the white point for the image. That's the point at which everything lighter is considered pure white.

The Blacks slider defines the black point, beyond which Camera Raw considers everything to be pure black.

Figure 5.7

The Basic pane contains many sliders, each affecting a different aspect of the image tone.

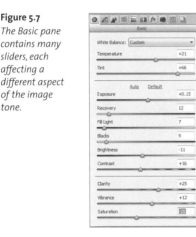

The Recovery slider brings back detail from highlights.

The Fill Light slider recovers detail from shadows.

Brightness and Contrast both affect the midtones as well. Both brightness and contrast can have a dramatic effect on the appeal of an image.

Clarity is an interesting setting, in that it enhances edges that are inherent in the file. In other words, it provides localized contrast. Be careful when you're working with portraits, as it can provide a little too much localized contrast in faces, emphasizing blemishes and wrinkles.

> **tip** If you're not sure what Clarity value to use, move the slider to the right until you see halos near the edge details, and then move the slider slightly to the left.

Vibrance and Saturation are similar. Saturation affects the saturation of the overall image, while Vibrance increases the saturation only in areas that aren't already saturated.

The histogram

Keep an eye on the histogram in the upper-right corner of the Camera Raw dialog box. The histogram displays the red, green, and blue channels in the selected image, and it updates dynamically as you adjust settings. As you move a tool over an area in the preview window, the RGB values for that area appear beneath the histogram.

Figure 5.8
Check the histogram to see how color is distributed in your image.

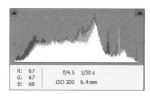

Making Local Tonal Adjustments

In addition to adjusting the overall tone of an image, you can adjust the exposure, brightness, clarity, or other tonal qualities for only a selected area using the Adjustment Brush and Graduated Filter tools. Use the Adjustment Brush tool to paint adjustments onto an area; use the Graduated Filter tool to apply adjustments more gradually over a region.

To make a local adjustment using the Adjustment Brush tool:

1. Select the Adjustment Brush tool.

2. In the Adjustment Brush pane, drag one or more sliders to new positions. In addition to tonal options from the Basic pane, you can adjust Sharpness, which enhances the edge definition to bring out details, and Color, which applies a tint.

 If you change your mind, double-click a slider to reset it to zero.

3. Set up the brush in the lower area of the Adjustment Brush pane. The brush size is measured in pixels.

 ▪ **Feather** determines how hard or soft the stroke is.

 ▪ **Flow** controls the rate at which the adjustment is applied.

 ▪ **Density** determines how transparent the stroke is.

 If you want to apply adjustments only to areas of a similar color, select Auto Mask.

4. Select Show Mask if you want to see which areas of the image you've painted over. You can toggle that option as you work.

5. Paint the adjustments onto areas in the image. When you release the mouse, a pin icon appears at the point of application.

6. Paint another area if you want to affect more of the image with the same adjustments.

7. If you change your mind about an area, click Erase at the top of the Adjustment Brush pane, and then paint over that area again.

8. Adjust any of the sliders to affect the areas you've painted.

To make local adjustments using the Graduated Filter tool:

1. Select the Graduated Filter tool from the toolbar.

2. In the Graduated Filter pane, drag the sliders you want to adjust.

3. Drag across the region of the photo you want to apply the adjustments to. The filter starts at the green dotted line and continues past the red dotted line. The adjustments are stronger at the green dotted line and get weaker as they approach the red dotted line.

4. Adjust any sliders to change the effect in the region.

 To expand, contract, or rotate the region, drag one of the dots.

Figure 5.9
Paint over the area you want to change, and then tweak the settings in the Adjustment Brush pane.

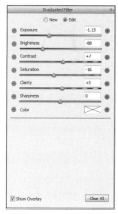

Figure 5.10
The Graduated Filter tool applies changes gradually across a region.

Sharpening Edges

The sharpening feature in Camera Raw gives you precise control over how much sharpening it applies and which edges it sharpens. You'll find all the sharpening controls in the Detail pane.

If Camera Raw is your last stop for the image, sharpen the image as much as you deem necessary. However, if you're planning to do additional work in Photoshop, be careful not to overdo the sharpening. Sharpen again in Photoshop just before you save the final image or prepare it for printing.

note I've put this section here because you're much more likely to sharpen images than to use the panes described in the section that follows. However, keep in mind that sharpening should usually be the last step in your workflow before you prepare an image for output.

Figure 5.11
To sharpen images, make adjustments in the Detail pane.

To sharpen an image in Camera Raw:

1. Double-click the Zoom tool in the toolbar to zoom in to 100 percent. You can zoom in more if you like, but the view must be at least 100 percent for sharpening changes to appear on the screen.

2. Use the Hand tool to position the image in the preview window so that you can see the area you're most concerned with sharpening. This can be an area that is the softest, an area most in need of sharpening, or an area you're afraid of oversharpening.

3. Shift the Amount slider far to the right. Don't worry about oversharpening at this point. You'll adjust the other sliders and then reduce the amount. Exaggerating the amount at first lets you clearly see what you're doing.

4. Adjust the Radius slider, which determines the pixel area Camera Raw analyzes. In an out-of-focus image, you may want to use a larger radius to exaggerate the halos around soft edges. If your image is already pretty sharp, use a lower radius. For most images, you should keep the Radius below 1 pixel.

5. Adjust the Detail slider, as needed. The Detail slider determines the amount of contrast on the edge. Even when Detail is set to 0, Camera Raw performs some sharpening. For most images, you should keep the Detail setting low.

6. Set the Masking level. This is the slider that makes the Camera Raw sharpening feature so useful. It gives you more precise control over sharpening, as you can restrict sharpening only to the edges. The greater the Masking setting, the fewer subtleties (such as skin texture and luminance noise) are sharpened.

 Press Alt (Windows) or Option (Mac OS) as you move the Masking slider to see what Camera Raw will sharpen.

7. Return to the Amount slider and reduce it. You should be able to see accurate sharpening now that you've adjusted the other sliders.

Adjusting Other Settings

There are several other panes in Camera Raw, providing more options for adjusting the tone, balancing color, reducing noise, and applying effects.

Tone Curve pane

You can remap the tonality of an image using parametric and point curves. To those who aren't geometry geeks, this pane can be a bit intimidating. If you do choose to experiment with this pane, remember that you can always reset the defaults if you aren't happy with the changes.

On the Parametric tab, move the sliders to adjust the highlights, lights, darks, and shadows. To change what is considered a highlight, light, dark, or shadow, move the control triangles at the base of the graph.

To reset the default for a slider, double-click it. To reset the default for a control triangle, double-click it.

On the Point tab, you can let Camera Raw make the changes: choose a Medium Contrast or Strong Contrast from the Curve menu to apply that curve. Or, click to add control points, and then drag them into a new custom curve. To reset the default, choose Linear from the Curve menu.

Detail pane

In addition to sharpening, which I covered earlier, the Detail pane includes noise reduction sliders. Luminance noise is the presence of

Figure 5.12
The Tone Curve pane.

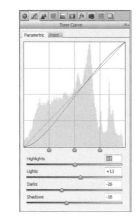

extraneous pixels that make an image look grainy; color noise is even more obvious—bits of color that are out of place. The noise reduction feature in Camera Raw is generally considered more accurate than the Reduce Noise filter in Photoshop.

As with sharpening, you need to zoom in to at least 100 percent to preview the changes you make when you reduce noise. Move the Luminance slider to remove luminance noise, and then adjust the Luminance Detail and Luminance Contrast sliders to restore some detail and contrast to the image. Move the Color slider to remove color noise, and adjust the Color Detail slider to restore detail you may have lost.

HSL/Grayscale pane

The HSL/Grayscale pane controls the hue, saturation, and luminance in your image.

Sliders on the Hue tab affect the quality of the color itself. For example, if you move the Oranges slider to the left, orange colors are darker; move it to the right, and orange colors are yellowish.

Sliders on the Saturation tab determine the saturation level of each color. To desaturate a color, move its slider all the way to the left; to fully saturate it, move the slider all the way to the right.

 You can create some stunning effects by desaturating all but one or two colors, or by oversaturating a single color.

Sliders on the Luminance tab affect how light each color is.

You can also use this pane to convert an image to grayscale. Select Convert to Grayscale at the top of the pane; then, adjust the sliders to change the luminance of the original color channels within the grayscale image.

Figure 5.13
The HSL/
Grayscale pane.

Split Toning pane

The Split Toning pane creates tinting effects in the shadows, highlights, or both. You can add tinting effects to either grayscale or color images, though the effect is more striking with grayscale images.

It can be easy to go overboard with these settings. Use a light touch. For most images, you'll do better with tinting effects in the shadows than in the highlights.

Figure 5.14
*The Split Toning
pane.*

Lens Corrections pane

This pane gives you both Chromatic Aberration and Lens Vignetting sliders.

Chromatic aberration, a fancy way of talking about red or blue fringing, occurs when light is bent inconsistently. Use the sliders to adjust the color balance and remove the fringe.

A *vignette* is a darker area around the edges of an image. You can use the Lens Vignetting sliders to remove a darker edge on the image—or to add one, if you want to focus the viewer's eye. Move the Amount slider to the right to remove a vignette or to the left to add one. Note that this feature does not recognize cropping, so if you've cropped your image, the vignette may not be even.

Figure 5.15
*The Lens
Corrections pane.*

Figure 5.16
You can add a vignette, a dark area around the edges, to focus the viewer's gaze on the center of the image.

Effects pane

Odd as it may seem to someone who's trying to remove noise and graininess from an image, you can actually add grain in Camera Raw. Just move the Amount slider to the right and then adjust the size and roughness.

Use post-crop vignetting to add a vignette to your cropped image. Move the Amount to the right to add a white border in an oval shape around your image; move it to the left to add a dark border. You can tweak the appearance of the vignette using the other sliders and the Style menu.

Figure 5.17
The Effects pane.

Figure 5.18
A light vignette around the cropped image.

Figure 5.19
A dark vignette around the cropped image.

Additional panes

The Camera Calibration pane lets you apply camera profiles to raw images. With an accurate camera profile, you can correct color casts and otherwise compensate for the behavior of the camera's image sensor. Working with camera profiles is far beyond the scope of this book, but if you're interested in using camera profiles, there are resources online to help you get started.

In the Presets pane, you can save groups of settings to apply to images quickly. To save a group of settings as a preset, first apply the settings to an image, and then click the New Preset icon at the bottom of the Presets

pane. In the New Preset dialog box, select which settings to include, and name the preset. To apply a preset, click it in the Presets pane.

 tip **You can apply a preset without even opening Camera Raw. In Bridge, select an image, and then choose Edit > Develop Settings > [preset].**

The Snapshots pane lets you record a photo at any point in the editing process so you can return to it. Click the New Snapshot button at the bottom of the Snapshots pane to create a snapshot, and then name the snapshot. To return to that image state later, just click the snapshot name in the Snapshots pane.

Synchronizing Settings across Images

If you are editing multiple images that were taken under the same lighting conditions, or that otherwise require the same edits, you can save considerable time by applying the same settings to all of them.

To synchronize settings across images:

1. Open all the images in Camera Raw.

2. Make the adjustments to one image.

3. Click Select All in the upper-left corner of the Camera Raw dialog box to select all the images in the filmstrip.

4. Click the Synchronize button.

5. In the Synchronize dialog box, select the settings you want to apply to all the images, and then click OK.

Figure 5.20

To quickly apply your settings to all the open images, click Synchronize.

Finishing Up in Camera Raw

When you've made your changes in Camera Raw, you can save the image in DNG, JPEG, TIFF, or PSD format. Or you can open the image in Photoshop, transferring it without saving it as a separate file. If you want to work with the image in Photoshop, you can open it as an image or as a Smart Object.

A Smart Object is a layer that can be modified nondestructively. If you open the image as a Smart Object in Photoshop, you can return to Camera Raw to adjust edits there simply by double-clicking the layer in Photoshop.

To save the edited image as a separate image file:

1. Click Save Image.

2. Select a destination folder for the new file.

3. Change the way the file is named, if you like. This dialog box is different from most Save As dialog boxes, because you can't just type in

a new name. However, you can choose from the menus in the File Naming area to add the date or a numbering scheme.

4. Choose a format and options related to it.

5. Click Save.

Figure 5.21
Name the file or files in the Save Options dialog box.

Save Options

Destination: Save in Same Location

Select Folder... C:\photos\jinx photos\

Save
Cancel

File Naming
Example: jinx forward shelf1.jpg

Document Name + 1 Digit Serial Number +

+

Begin Numbering: 1

File Extension: .jpg

Format: JPEG

Quality: 8 High

To open the image in Photoshop, click Open Image.

To open the image as a Smart Object in Photoshop:

1. Press the Shift key to change the Open Image button to Open Object.

2. Click Open Object.

 tip To change the button's default, so that it reads Open Object without the Shift key, click the blue underlined text at the bottom of the dialog box. Then select Open in Photoshop as Smart Objects.

Open Images Cancel Done Open Objects Cancel Done

Figure 5.22 *You can open Camera Raw images in Photoshop as Smart Objects or as standard Photoshop images.*

Painting

Painting calls to mind an artist with an easel at the ocean, or a group of college students in coveralls attacking the side of a house. Some of the painting you do in Photoshop resembles the first image, but I wouldn't count on getting the house painted digitally. Still, when it comes to Photoshop, the definition of painting is quite broad. Anything that applies color to the canvas is considered painting, whether you create a gradient, use the Brush tool, or apply a fill.

If you're artistic and you want to capture the sense of working on a more traditional easel, you'll appreciate a new feature in Photoshop CS5. More realistic bristle tips can create bristle streaks as you paint, as your brush would on a physical canvas. The new Mixer Brush tool even makes it possible to add color that interacts with the color below it, as if you were painting with watercolors.

About the Painting Tools

When you think of painting tools, you probably think of paintbrushes, rollers, or possibly those sprayers you might use to paint the exterior of a house. But in Photoshop, any tool that applies image color is considered a painting tool.

The Brush and Mixer Brush tools are obvious painting tools. The Pencil tool is similar because it also applies color with brushstrokes. The Gradient tool applies graduated color to a large area. The Fill command and Paint Bucket tool also fill large areas with color.

Many of the tools in Photoshop give you options for brush size and hardness, and often presets as well. Other options for painting tools in the options bar determine how color is applied.

Selecting Brush Tips and Attributes

In real life, you choose brushes of different sizes, with different tip shapes, for different tasks. For example, you wouldn't want to paint a wall with the brush you might use to apply detail to a ceramic figurine. Likewise, watercolor artists use fan brushes and brushes with chisel tips to achieve very different effects.

In Photoshop, you can select a brush preset from the Brushes pop-up menu in the options bar; there you can also change the brush size, and specify how hard or soft the tip is. For more control over brush tips, though, get to know the Brush and Brush Presets panels.

In the options bar, you can select a blending mode, opacity percentage, flow rate, airbrush option, and tablet pressure options. The blending mode and opacity are similar to blending modes and opacity you apply elsewhere.

Figure 6.1 *When the Brush tool is selected, you can select flow, opacity, and other settings in the options bar.*

The Flow option determines the rate at which color is applied when you paint; the amount of color builds up based on the flow rate. This concept is a little more complicated than it might appear: For example, if you set the opacity to 25 percent and the flow to 100 percent, every time you paint an area, its color moves 25 percent toward the brush color; unless you release the mouse button and stroke the area again, it won't exceed the 25 percent opacity. So in this case, if you keep the mouse down and stroke an area four times, its color will equal the maximum opacity for the color. But if you set both opacity and flow to 25 percent, each time you stroke, the color will have an opacity of 25 percent, based on a full strength of 25 percent of the color. If you stroke four times, you'll get to the full flow, which is at 25 percent of the color in the foreground swatch.

When you select the Airbrush option, the paint builds up as if you were using an airbrush. The color accumulates as you hold down the mouse button (kind of like pressing the button on a spray can, but without the painted finger afterward).

If you're using a stylus, such as a Wacom tablet, select the tablet pressure buttons to override opacity and size settings based on how much pressure you apply.

Brush presets

Photoshop includes several brush presets. A *brush preset* is a saved brush tip that already has its shape, hardness, and other attributes defined. You can use the brush presets included with the application or create your own. You can even use a brush preset as a starting point, and

then modify it for your use—but note that, unless you save the revised settings as a new preset, the change is temporary.

Select a brush preset in the Brush Preset Picker in the options bar, from the Brush panel, or from the Brush Presets panel. The Brush Preset Picker in the options bar is a quick way to select a brush and make minor changes to its size and hardness. The Brush tool gives you many more options for customization. The Brush Presets panel shows multiple brush tip previews so you can see how each brush tip paints.

Figure 6.2

The Brush Preset Picker, available from the options bar.

Figure 6.3

The Brush panel.

Figure 6.4
The Brush Presets panel.

To save a custom brush preset:

1. Select the brush attributes you want to use, including size, shape, and bristle qualities.

2. Choose New Brush Preset from the Brush panel menu.

3. Name the brush, and click OK.

To see samples of brush presets before you select them, open the Brush Presets panel. You can open it by choosing Window > Brush Presets, or by clicking Brush Presets in the Brush panel.

Figure 6.5
Preview brush tips in the Brush Presets panel.

If you're looking for a named preset, change the way they're displayed in the Brush Presets panel. Choose Large List from the panel menu to see the brush presets' names.

Figure 6.6

To look for a specific brush, such as one you've created, view the presets by name.

In addition to more traditional brush shapes, you can create a brush tip from an image. Select the area you want to use as a custom brush, up to 2500 pixels by 2500 pixels. Then, choose Edit > Define Brush Preset. Name the brush. Brush tip images can only be grayscale, so color selections are converted. When you use the brush, it will paint in the foreground color. Image brush tips are great for creating things like borders. To make things more interesting, experiment with scatter and jitter options for your custom brush tip.

Brush tip options

The combinations of brush tip shapes are wide ranging. You can control everything from the size and angle of the brush to scattering and noise attributes. These quick definitions should give you enough information to experiment—and that's where the fun really begins.

Figure 6.7

You can create a brush tip from an image, which is especially useful if you're making patterned paper or adding a border to artwork.

Figure 6.8

Set up the brush tip any way you want it in the Brush panel.

Brush Tip Shape settings

These are the basic qualities of a brush that has no bristle tip settings. (Some of the settings, such as size and spacing, apply to both traditional brush tips and bristle tips.)

- **Size:** Controls the size of the brush.
- **Flip X:** Changes the direction of a brush tip on its *x*-axis.
- **Flip Y:** Changes the direction of a brush tip on its *y*-axis.
- **Angle:** Determines the angle of the stroke. Think about how the angle of a brush works in calligraphy to create a chiseled stroke.
- **Roundness:** Determines how round the brush tip is. For a circular brush, use 100 percent. For a linear brush, use 0 percent. Anything in between gives you an ellipse.
- **Hardness:** Sets the size of the brush's hard center. This determines how sharp or how soft the edges are as you paint.
- **Spacing:** Determines the distance between brush marks in a stroke. You can set up a brush to skip areas, as in a border or pattern. Larger numbers create more skipped areas.

Bristle Qualities

These are the qualities that give you the more realistic, natural-looking bristle strokes. The options aren't shown by default in the Brush panel; to see them, click one of the bristle shape presets.

- **Shape:** How the bristles are arranged, such as fan or a flat angle
- **Bristles:** How dense the bristles are
- **Length:** How long the bristles are
- **Thickness:** How wide each individual bristle is

- **Stiffness:** How flexible the bristles are
- **Angle:** The angle of the brush tip itself

 The Bristle Brush preview shows the brush tip as you paint, so you can see the tip and its current stroke angle.

Figure 6.9
The Bristle Brush preview.

Shape Dynamics

Changes the shape of the brush as you paint. Options include Size Jitter, Angle Jitter, Roundness Jitter, and Tilt Scale. To change these settings, select Shape Dynamics in the list on the left.

Scattering determines the number and placement of marks in a stroke.

Figure 6.10
To adjust the jitter and roundness of the brush as you paint, select Shape Dynamics in the list on the left in the Brush panel.

Jitter percentages specify the randomness of dynamic elements: 0 percent means no variation; 100 percent means as much randomness as possible.

Click one of the categories at the left of the Brush panel to set control options for that category.

Using the Brush or Pencil Tool

The Brush tool and Pencil tool are quite similar, and they both resemble their physical-world counterparts. You can use a brush preset with either of them, and they both paint the current foreground color. The only real differences between them are that you can adjust the hardness of the Brush tool, but the Pencil tool is always 100 percent hard. And, of course, bristle tips are not available with the Pencil tool.

Figure 6.11
When the Pencil tool is selected, there's an Auto Erase option in the options bar.

The Pencil tool also includes an Auto Erase option, which isn't all that intuitive. To use it, select Auto Erase in the options bar, and then start erasing. If you use the tool in an area that contains the foreground color, the tool erases it to the background color. Okay, that part makes sense—it's as if you flipped the pencil over to use the little pink rubber eraser on the end. Where it gets weird is that if you use the tool in an area that doesn't include the foreground color, it paints with the foreground color. That's not erasing, in my book. It's more like one of those two-color pencils that were all the rage when I was a kid—one end is red and the other is blue.

Using the Mixer Brush Tool

The Mixer Brush tool , new in Photoshop CS5, doesn't just add color to an image—it actually mixes colors you add with colors already in the image, as if the page contained wet paint. You can determine how the mixing occurs by changing the wetness of the brush and changing the Load and Mix options.

> **tip** The bristle tip options are especially effective when you're using the Mixer Brush tool as well. Combining different bristle settings and brush tips with the options in the options bar give you great artistic flexibility.

Let's talk about those options in the options bar:

■ **Wet** controls how much paint the brush picks up from the canvas. If you choose 0 percent, the Mixer Brush just paints as if it were a regular Brush tool. At 100 percent, the Mixer Brush picks up all the paint from the canvas, as well as the paint already on the brush.

■ **Load** determines how much paint the brush holds when you begin painting. As with a physical brush, you run out of paint as you paint with it. The Load setting in Photoshop sets how much paint is in that brush to begin with.

■ **Mix** controls the ratio of paint from the canvas with paint from the brush.

Load Brush after Each Stroke

Clean Brush after Each Stroke

Figure 6.12 *Select the settings for the Mixer Brush tool in the options bar.*

You can set the Wet, Load, and Mix options separately. In many cases, though, you'll do just fine using one of the standard combinations from the pop-up menu in the options bar. When you select Dry in the options bar, Wet becomes 0 percent and Load becomes 50 percent; because Wet is 0 percent, Mix isn't applicable. With Dry selected, the Mixer Brush works like a regular brush. Very Wet, Heavy Mix goes to the other end of the spectrum; when you select that option, Wet is 100 percent and so is Mix, while Load is 50 percent.

Figure 6.13

Painting with the same brush with Dry, Moist, and Very Wet selected. The Dry brush paints opaquely. Moist and Very Wet mix the paint color with the white background to varying degrees.

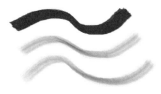

In the physical world, if you dip a brush in a paint can, that paint remains on the brush until you completely paint it out (which is usually impossible to do) or clean the brush. The same is true with the Mixer Brush tool in Photoshop. To remove the paint load from a brush, choose Clean Brush from the pop-up menu in the options bar. To replace the paint load in a brush, sample a different color.

You can have Photoshop clean the brush after each stroke: select the Clean Brush icon in the options bar. To load the brush with the foreground color after each stroke, select the Load Brush icon in the options bar. Conveniently, these options are both selected by default.

Applying Gradients

A *gradient* is a gradual blend from one color to another. It's not limited to two colors, either; a gradient can gradually move through multiple colors. Or, a gradient can move from one color to transparency.

Figure 6.14
A gradient from one color to another.

Figure 6.15
A gradient that moves through multiple colors.

The easiest way to apply a gradient in Photoshop is to use the Gradient tool ▢.

To apply a gradient with the Gradient tool:

1. Select the area to which you want to apply the gradient. If you don't select an area, Photoshop applies the gradient to the entire layer.

2. Select the Gradient tool.

3. Select a gradient style from the Gradient Picker in the options bar.

Figure 6.16
The Gradient Picker displays several gradient styles.

4. Select a gradient shape in the options bar. You can create linear, radial, angle, reflected, or diamond gradients. The gradient shape determines how the colors move from one to another.

Figure 6.17
Linear gradient.

Figure 6.18
Radial gradient.

Figure 6.19
Angle gradient.

Figure 6.20
Reflected gradient.

Figure 6.21
Diamond gradient.

5. Select the foreground and background colors for the gradient, if it's moving from just one color to another. Or, click the gradient sample in the options bar to open the Gradient Editor and make changes there.

6. Drag the Gradient tool across the selection or the layer to create a gradient. The point where you begin drawing is the starting point in the gradient, and the point where you lift the mouse is the end point for the gradient.

Using the Gradient Editor

Click the gradient sample in the options bar to open the Gradient Editor. In the Gradient Editor dialog box, you can add color stops to create more color transitions in the gradient, change the colors, and change other gradient properties.

Figure 6.22

You can adjust the way the colors and opacity change in a gradient using the Gradient Editor.

Gradient presets

Opacity stops

Color stops

Change settings for selected opacity stop

Change settings for selected color stop

- To add a color stop, click below the color ramp.

- To change the color of a color stop, double-click it and then select a new color from the color picker, and click OK.

- To change the transition to transparency (if there is one), move the opacity stops above the color ramp.

- To change the value of an opacity stop, select it, and then choose a new Opacity percentage in the Stops area of the dialog box.

- To save a gradient to use again, click Save. To load one you've already saved, click Load.

 tip You can also create a noise gradient, which contains randomly distributed colors within the range in the gradient. To do so, choose Noise from the Gradient Type pop-up menu in the Gradient Editor.

7

Applying Effects

Whether you're aiming for realism or quite the opposite, you can create some amazing effects in Photoshop using filters, layer styles, blending modes, opacity settings, and the new Puppet Warp feature. Though this book isn't long enough to detail every option, I hope there's enough information here to inspire you to explore the possibilities. If you want detailed information about a particular filter, layer effect, or blending mode, check out the very helpful Photoshop Help.

Filters

There are so many kinds of filters—practical retouching filters, freaky distortion filters, sophisticated artistic filters—and the only thing they have in common is that they change the look of your image. When you

apply a filter to a standard image or layer, it changes the actual pixels, so make sure you're working in a copy of an image or a duplicate layer. If you want to apply filters nondestructively, so that the original pixels remain untouched and you can continue to tweak settings at any time, work with Smart Objects and apply Smart Filters.

What's so smart about Smart Objects?

A Smart Object is a Photoshop layer, containing image data from either raster or vector images. But it's not just like any other layer. Smart Objects make it possible to edit layers nondestructively, so you can change your mind and undo or modify the changes you've made later. A Smart Object preserves the original content with the original characteristics, no matter how many changes you make to it.

Smart Objects give you great flexibility. You can use them to:

- Scale, rotate, skew, or perform any other transformation without compromising the original image quality because the transformation doesn't change the actual pixels.

- Use vector artwork from Illustrator without rasterizing it in Photoshop.

- Apply Smart Filters, which can be modified at any time.

- Link multiple instances of Smart Objects, so that editing one affects them all.

If Smart Objects are so groovy, why not convert all your layers to Smart Objects? Unfortunately, they have some limitations. You can't perform any operations that actually change pixel information, such as painting or cloning, directly on a Smart Object layer.

tip You can convert an image to a Smart Object so that you can apply a Smart Filter to it: Choose Filter > Convert for Smart Filters. Click OK when Photoshop tells you it's about to convert the layer to a Smart Object.

To apply a filter, you can simply choose it from the Filter menu. Any filter listed with an ellipsis in the menu has further options that you can select to change the way the filter is applied. Some filters automatically open the Filter Gallery so that you can preview the filter effect and adjust its settings there.

You can go directly to the Filter Gallery to preview multiple filters and have immediate access to all the options for each filter. Not all filters are available in the Filter Gallery. For example, sharpening filters aren't included in it. But most of the artistic filters are there.

Available filters Selected filter Filter settings

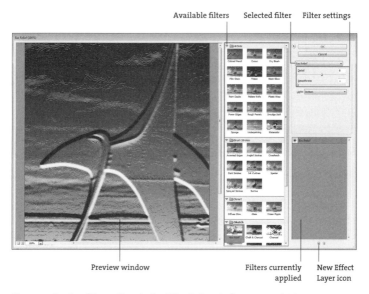

Preview window Filters currently New Effect
applied Layer icon

Figure 7.1 *Preview filter options in the Filter Gallery before you apply them.*

To use the Filter Gallery:

1. Choose Filter > Filter Gallery.

2. Select a category and then a filter.

3. Adjust the settings on the right.

4. To apply the filter, click OK. To change the filter, select a different one. To add a filter, click the New Effect Layer icon at the bottom of the Filter Gallery window.

 Filters won't work with Bitmap-mode or indexed-color images. Additionally, some work only with RGB images. You can apply any filter to an 8-bit image, but some won't work with 16-bit images or 32-bit images.

Figure 7.2 *The same image with the Chrome and Poster Edges filters applied.*

To reduce the effect of a filter, choose Edit > Fade [filter name]. This command is not available with Smart Filters, because you can continue to edit them. You can change the opacity and blending mode in the Fade dialog box; be sure to select Preview so you can see the effect of your changes.

For a list of all the filters included with Photoshop and their effects, see Photoshop Help.

Layer Styles

Add depth or interest to your image with a drop shadow, glow, bevel, or other layer effect. When you apply a layer effect, it changes the appearance of the entire layer, and if you change the contents, the effect is applied to the modified contents.

To add a layer effect:

1. Select the layer in the Layers panel.

2. Choose Layer > Layer Style > [layer effect name]. Or click the Add Layer Style icon at the bottom of the Layers panel.

3. Select settings for the layer style. Select the Preview option to see how the changes affect the layer.

4. Click OK or select an additional layer effect from the list on the left. If you add an effect, adjust its settings as well, and then click OK.

Figure 7.3

Adjust settings for one or more layer effects in the Layer Style dialog box.

When you've applied a layer style to a layer, the layer effects icon *fx* appears next to its name in the Layers panel. You can expand the style to view or edit the effects that compose the style. You can also show or hide each effect.

Figure 7.4
Layer effects appear in the Layers panel, where you can show or hide them.

tip If you frequently use the same drop-shadow settings, for example, click New Style in the Layer Style dialog box to save the style with all its settings. Then select your custom style in the Styles panel to apply it.

Using preset styles

Photoshop includes a number of style presets in the Styles panel. They're grouped by function, so you can select styles that are appropriate for creating Web buttons or adding effects to text. To load a library of styles, choose the library from the Styles panel menu. (Choose Window > Styles to open the panel.)

Figure 7.5
The Styles panel.

 You can't apply layer styles to a background layer, locked layer, or layer group.

To apply a style from another layer, Alt-drag (Windows) or Option-drag (Mac OS) the style from one layer to another in the Layers panel.

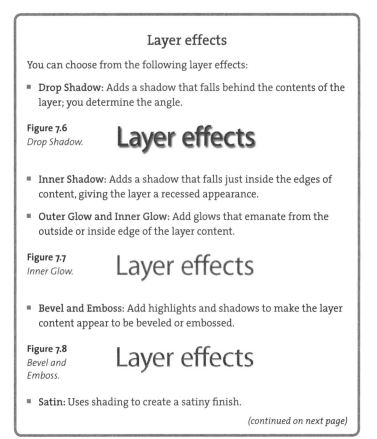

Layer effects

You can choose from the following layer effects:

- **Drop Shadow:** Adds a shadow that falls behind the contents of the layer; you determine the angle.

Figure 7.6
Drop Shadow.

- **Inner Shadow:** Adds a shadow that falls just inside the edges of content, giving the layer a recessed appearance.

- **Outer Glow and Inner Glow:** Add glows that emanate from the outside or inside edge of the layer content.

Figure 7.7
Inner Glow.

- **Bevel and Emboss:** Add highlights and shadows to make the layer content appear to be beveled or embossed.

Figure 7.8
Bevel and Emboss.

- **Satin:** Uses shading to create a satiny finish.

(continued on next page)

Layer effects (continued)

- **Color, Gradient, and Pattern Overlay:** Fills the content of the layer with a color, gradient, or pattern.

- **Stroke:** Outlines the content of the layer using color, a gradient, or a pattern.

Figure 7.9
Stroke.

Layer effects

Blending Modes

Blending modes change the way layers play together. Some intensify color and others replace it. Some adjust contrast or lighting. The right blending mode can make an over-the-top filter much subtler, or give some punch to a drab image.

Blending modes pop up everywhere in Photoshop—and with good reason: they dramatically change the way your choices affect the image.

- You can set the blending mode for a layer (affecting the way it interacts with all the layers beneath it) by selecting the layer and changing the blending mode in the Layers panel.

- To change the blending mode for a tool, choose an option from the Mode menu in the options bar.

- Set a blending mode for layer effects in the Layer Styles dialog box.

Figure 7.10

Choose a blending mode in the Layers panel, options bar, or Layer Styles dialog box.

- **Normal modes:** The Normal modes are Normal and Dissolve. Normal hides pixels unless the top layer includes transparency. Dissolve randomly replaces pixels with the color of either layer, so the top layer appears to dissolve into the one beneath it.

Figure 7.11
In this image, flowers are on a layer above a grayscale pattern layer. With the Normal blending mode selected, all you see are the flowers.

- **Darkening modes:** The Darkening modes always result in a darker image. Darken, Multiply, Color Burn, Linear Burn, and Darker Color all darken in different ways.

Figure 7.12
The same flowers look very different with the Color Burn blending mode applied.

- **Lightening modes:** The Lightening modes always result in a lighter image. Lighten, Screen, Color Dodge, Linear Dodge, and Lighter Color lighten different parts of the image.

Figure 7.13
The same image, this time with Lighter Color selected.

- **Overlay modes:** The Overlay modes result in greater contrast. Overlay, Soft Light, Hard Light, Vivid Light, Linear Light, Pin Light, and Hard Mix produce interesting and varied appearances.

Figure 7.14
Hard Mix gives a very different effect.

- **Difference modes:** The Difference modes compare the colors in the layers with each other. Difference creates greater contrast, and Exclusion results in lower contrast. Subtract subtracts pixel value from one layer with another and Divide divides the pixel values.

Figure 7.15
This is the same image, but with Divide as the blending mode.

- **Hue modes:** The Hue modes affect the actual color values. Hue, Saturation, Color, and Luminosity affect the respective attribute of the image.

Figure 7.16
Here's the same image with Luminosity, an effect I like.

Opacity

The Opacity setting determines how opaque (or, conversely, how transparent) a layer or attribute is.

- To change the opacity of a layer, select it and then change the Opacity in the Layers panel.

- To change the opacity for the content but not affect layer effects, use the Fill slider in the Layers panel.

- To change the opacity for a tool, change it in the options bar.

You'll also see Opacity sliders in the Gradient Editor, the Layer Styles dialog box, and many other dialog boxes and panels in Photoshop.

Figure 7.17
Change the opacity for a layer in the Layers panel. Change it for a tool in the options bar.

tip Press a single number key to set a tool's opacity in multiples of 10 percent. Press 2 to set it to 20 percent, 5 to set it at 50 percent, and so on.

Puppet Warp

The new Puppet Warp feature provides a hands-on method of distorting an image, sometimes in compelling ways. You can distort any portion of a layer, or rotate an area. To warp the image, you place pins in a mesh; the pins let you control movement in one area while preventing it in another area.

To use Puppet Warp:

1. Select the layer you want to transform, and then choose Edit > Puppet Warp. The mesh appears.

note You can't apply Puppet Warp to a Background layer. Either duplicate the layer or convert it to a regular layer to apply Puppet Warp to its contents.

2. Click where you want pins to anchor, as well as places you want to transform.

Figure 7.18
Place pins on the Puppet Warp mesh.

3. Drag pins to deform the mesh and the layer with it.

Figure 7.19
Drag a pin to deform the contents of the layer.

4. To rotate the mesh around a pin, select the pin you want to pivot around. A black dot appears in the center of the pin when you've selected it. Press Alt (Windows) or Option (Mac OS). A larger circle appears around the pin, with a curved double arrow next to it. Continue pressing Alt or Option, and drag to rotate the area around the pin. You can also enter an angle of rotation in the options bar.

5. When you're satisfied with your distortions, press Enter or Return, or click the Commit Puppet Warp button in the options bar.

 tip **You can also apply Puppet Warp to layer and vector masks. You can apply them to Smart Objects to distort areas nondestructively.**

Control the mesh using the following settings in the options bar:

- **Mode** determines how elastic the mesh is. Choose Distort if you're working with a wide-angle image or otherwise want a very elastic mesh. Rigid holds the mesh tighter.

- **Density** determines how many points are on the mesh. You'll get more precision with more points, but the distortion will take longer to process.

- **Expansion** affects the expansion or contraction of the outer edge of the mesh.

- **Show Mesh** displays the mesh. You may want to hide the mesh to preview your transformation before committing to it.

Figure 7.20 *Configure the mesh in the options bar.*

To remove a pin, select it and press Delete. Or press Alt or Option, and click when the scissors icon appears.

To start over, click the Remove All Pins button in the options bar.

8

Merging Photos

You can work with more than one photo at a time. In fact, that's where a lot of the fun is. There are many reasons you may want to combine two or more images. In addition to creating collages, you can merge photos to replace the background of an image, create a panorama, or use the best aspects of multiple group shots. You can also merge images with multiple exposures to reveal all the shadow and highlight details, and you can use a similar technique to increase the depth of field.

Adding Layers from Other Images

Dragging a layer from one file into the image window of another is remarkably easy. When you do so, Photoshop adds the content to a new layer in the destination file.

note Photoshop always adds new layers directly above the selected layer.

To add a layer from another image:

1. Open both images in Photoshop.

2. Choose a 2-up option from the Arrange Documents pop-up menu in the application bar, so that you can see both images.

Figure 8.1 *Display both images at the same time.*

3. Drag the layer from one image window onto the other. Press Shift as you drag if you want to center the image you're copying in the target image window.

Figure 8.2
Drag the layer from one image onto the other.

4. If you need to resize the layer, choose Edit > Transform > Scale. Then either use the transformation handles to scale the layer, or enter values in the options bar. You can use the Move tool to position the layer wherever you want it.

Figure 8.3
Resize and position the layer where you want it.

 Adding a layer from another image works best if they're in the same color mode.

Replacing the Background

If you can't afford a vacation, use Photoshop to move your photo (if not your physical self) to a luxurious destination. Or send a science-fiction fiend to outer space. If you have a photo of a person or an object, you can replace its background with any other image.

To combine a foreground object with a different background, you first need to separate the foreground object from its original background, and then import the foreground object into the background image. You can use different methods to isolate the foreground object, including selecting it or erasing the background.

To remove the foreground object from the background using a selection tool:

1. Open the images that contain the foreground and background you want to use.

2. Choose a 2-up option from the Arrange Documents pop-up menu in the options bar, so you can see both images.

3. Select the foreground object you want to use, using any selection tool.

4. With the Move tool, drag the selection onto the background image. Photoshop adds the image to its own new layer in the background image.

Using the Background Eraser tool

Another way to isolate the subject of a photo is to erase its background with the Background Eraser tool . As you drag across an area with the tool, pixels become transparent. That, in itself, is cool, but what's better is that the Background Eraser tool recognizes the edges of an object, so you can erase the background without affecting the fore-ground object.

As you paint, the Background Eraser tool samples the color in the center of the brush, and then it deletes that color anywhere in the areas you brush. How similar the colors need to be depends on the Tolerance percentage you select; whether the pixels need to be contiguous depends on the Limits mode. The Background Eraser tool also prevents color halos from forming around the foreground object.

tip If the background is a similar color to the foreground, lower the tolerance value as you paint around the edge of the foreground.

Figure 8.4
Paint around the foreground with the Background Eraser tool.

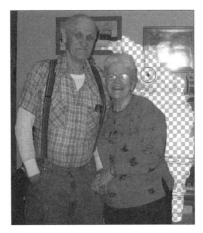

To use the Background Eraser tool:

1. Select the layer that contains the background you want to erase.

2. Select the Background Eraser tool.

3. Select a brush tip using the Brush pop-up menu in the options bar.

4. Choose a Limits mode. If you want to erase only areas that are connected to each other, choose Contiguous.

5. Choose a Tolerance percentage. A lower value limits the pixels erased to those that are very similar to the sampled color; a higher value erases more pixels.

 The Protect Foreground Color option prevents you from erasing colors that match the current foreground color in the Tools panel.

6. Choose a Sampling option.

 - **Continuous** samples colors as you drag.

 - **Once** samples only the color at the center of the brush when you first click.

 - **Background Swatch** doesn't sample at all; it erases only pixels that contain the current background color.

7. Drag through the area you want to erase. The center sampling point, or hot spot, appears as a crosshair in the brush shape.

8. Add a new layer to use for the background, if you don't already have one in place, or drag the layer you've been working with onto another image.

Merging Group Photos

Thanks to the Auto-Align Layers feature, you can easily combine the best elements from multiple group shots. Say, for example, you took two group photos of your basketball team. In one of the photos, three people have their eyes closed and another is turned to watch a car drive down the street. Fine, you'll use the other photo. But in that one, two different people have their eyes closed and one is stifling an unfortunate yawn. All is not lost. You can pick the photo you consider to be the better one to be your base, and then replace the elements that are less than perfect with the better versions from the other photo.

Figure 8.5
It's hard to take a group photo where no one looks goofy.

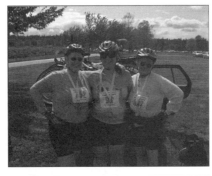

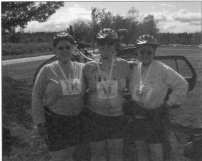

Figure 8.6
Merging two photos increases the odds that no one will be embarrassed.

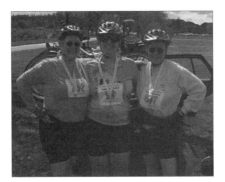

To merge group photos:

1. Open both of the photos in Photoshop.

2. Choose a 2-up display option from the Arrange menu in the options bar, so you can see both images.

3. Drag one image into the other image window, so they're separate layers in the same image.

4. Close the image window you no longer need (not the one with the two layers!).

5. Shift-click to select both layers in the Layers panel.

6. Choose Edit > Auto-Align Layers. Usually you'll be fine accepting the Auto option. Click OK to close the dialog box. Photoshop aligns the layers.

7. Make sure the photo you deem best is the top layer.

8. Select the Eraser tool in the Tools panel, and select brush attributes.

9. Erase a compromised face (such as a blinker) to reveal the better version in the image below.

10. Continue erasing until you've got the composite you want. If people shifted between shots, you may have to erase more than you'd expect so that you don't give someone two arms, for example.

11. Review the entire photo to ensure that the people in your group and the background behind them look believable. Make any additional erasures (or undo any erasures) as needed.

Creating a Panorama

Some vistas are too wide for a single shot. Photoshop includes a Photomerge feature that lets you stitch together multiple images to create a wide panorama. It's a cool and easy feature. In fact, I go out of my way to find excuses to use it.

To create a panorama from multiple photos:

1. Take your photos. Make sure they overlap at least a little bit, so Photoshop will be able to align them and to put them in the right order.

2. In Photoshop, choose File > Automate > Photomerge.

3. In the Photomerge dialog box, select a Layout option.

 For the Layout option, Auto often does a great job, as Photoshop applies either a Perspective, Cylindrical, or Spherical layout, depending on the photos. But you can change the Layout option to optimize it for the types of images you're working with. In fact, you can experiment. When you run Photomerge, Photoshop creates a brand-new, separate file. So, you can run it multiple times using different Layout options and use the results you prefer.

 Basically, here's what the layout options do:

 - **Perspective** uses one image as a reference image, and then transforms the others to match overlapping content.
 - **Cylindrical** displays individual images as if they were on an unfolded cylinder, reducing the potential for a "bow-tie" distortion. This option is best if you have a very wide panorama.
 - **Spherical** aligns and transforms the images as if they mapped the inside of a sphere. Use this for 360-degree panoramas.

- **Collage** aligns the layers, matches overlapping content, and then rotates or scales layers to fit.

- **Reposition** aligns layers and matches overlapping content, but it doesn't stretch or skew or otherwise transform the layers.

Figure 8.7

Experiment with options in the Photomerge dialog box.

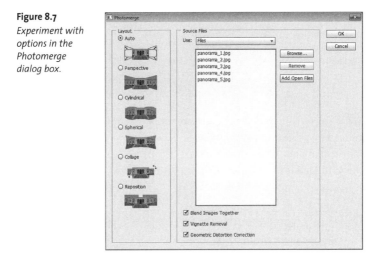

4. In the Source Files area of the Photomerge dialog box, click Browse. Navigate to and select the images you want to combine.

5. At the bottom of the dialog box, select Blend Images Together and, if you like, Vignette Removal and Geometric Distortion Correction.

> **note** **Vignette Removal removes darkened edges. Geometric Distortion Correction compensates for barrel, pin cushion, or fish-eye distortion. Generally, it's a good idea to select both of these options.**

6. Click OK. Photoshop opens all the images, finds the overlapping areas, aligns them, and merges the images seamlessly. It's doing some hard work, so you may have to wait a few minutes.

Figure 8.8

Photoshop blends your photos together, making it easy to create panoramas.

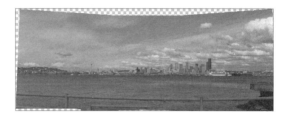

There are likely to be areas of transparency near some of the edges, depending on how Photoshop aligned the images. You can crop out any transparent areas. You can also add extensions to sky, sea, or grass, using the Auto-Blend Layers feature to blend the edges well.

Merging Multiple Exposures

Human eyes adapt to different brightness levels on the fly, so we can see the detail in shadows and highlights. But cameras and computer monitors—no matter how amazing—don't have this ability. Their dynamic range, the range of tones between dark and bright regions, is much more limited.

Photoshop includes a feature that lets you create high dynamic range (HDR) images, so that your images appear more as the scene would if you were viewing it in reality. To create an HDR image, you snap multiple photographs, capturing the same scene at different exposures, and then combine the detail revealed in each photo into a single image.

To create an HDR image:

1. Take at least three photos with different exposures: one that is under-exposed, one that is overexposed, and one with middle exposure.

tip **Many cameras can bracket exposures automatically to give you three or more shots for a single scene. If your camera has a priority setting, use aperture priority for consistency. A steady shot makes your life easier, so use a tripod if you can.**

2. In Photoshop, choose File > Automate > Merge to HDR Pro.

3. In the Merge to HDR Pro dialog box, browse to the images with different exposures. Select them all, and click Open.

4. Make sure Attempt to Automatically Align Source Images is selected, and then click OK.

 You'll see Photoshop open each of the files briefly and then merge them into a single image, which appears in the Merge to HDR Pro dialog box. The dialog box also shows you the images you merged.

Figure 8.9

The Merge to HDR Pro dialog box displays the merged image, the original images, and settings to adjust the tone and color in your final image.

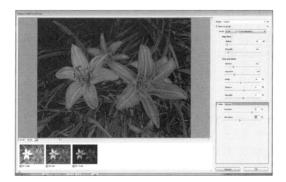

5. Adjust the settings in the Merge to HDR Pro dialog box to get the look you want.

 ■ The **Edge Glow** settings determine whether and how a glow effect is applied.

 ■ The **Tone and Detail** settings affect the overall tone of the image, and determine how much detail is revealed in the shadows and highlights.

 ■ The **Color** settings change the color intensity.

 note For more advanced tweaking, click the Curve tab to modify a histo-gram that displays the luminance values.

6. When you're happy with the image, click OK to accept the changes.

7. Save your new file. The original images remain untouched.

Increasing Depth of Field

When you're taking a photo, you often have to choose between focus-ing on the background and focusing on the foreground. If you want the entire image to be in focus, however, you can combine two photos in Photoshop.

To increase the depth of field:

1. Take two photos, one with the background in focus and one with the foreground in focus.

tip Though Photoshop does its best to align layers, you'll get the best results if you take the original images with a tripod to keep them consistent.

Figure 8.10

Use the Auto-Align and Auto-Blend features to combine background focus and foreground focus.

2. Open both images in Photoshop, and drag one into the other, so that each image appears on a different layer.

3. Select the layers in the Layers panel, and choose Edit > Auto-Align Layers.

4. In the Auto-Align Layers dialog box, select an option based on the images. In most cases, Auto is fine.

5. Click OK to align the layers.

6. With both layers selected in the Layers panel, choose Edit > Auto-Blend Layers.

7. In the Auto-Blend Layers dialog box, select Stack Images and Seamless Tones and Colors. Then click OK.

9

Preparing Images for the Web

When you're working with online images, you need to strike a balance between quality (which you want to be as high as possible) and file size (which you want to be as small as possible). You also need to save files in formats that can be viewed by Web browsers, of course.

You can optimize images for the Web as they are, or you can prepare images as navigation tools for Web sites. Either way, end by optimizing the images just before uploading them.

If you're designing a Web site, use layers and slices to create hyperlinks and buttons. You can also create animated GIF or QuickTime movies from images in Photoshop.

Slicing Images

If you want to use areas of an image to link to other pages or images, slice it. You can also use slices to optimize different parts of an image with different settings.

A *slice* is a rectangular area of an image that you define based on layers, guides, selections, or the Slice tool. When you export a sliced image, Photoshop saves each slice as a separate file and creates an HTML table or Cascading Style Sheet (CSS) code to display the sliced image.

Figure 9.1
Slices are rectangular areas on an image.

To see the slices, select the Slice tool or Slice Select tool . Each slice has a number and a badge. User slices have blue badges; auto slices have gray badges. Each slice is numbered, beginning with 1 in the upper-left corner of the image. (As you create more slices or divide existing slices, the slice numbers shift accordingly.)

Figure 9.2
*Each slice
has a badge
that provides
information
about that slice.*

A small mountain symbol on a badge indicates that the slice contains content; an X indicates that it doesn't. A box with a page corner turned up means the slice was created from a layer. An infinity symbol indicates that the slice is linked to other slices for the purposes of optimization.

Creating slices

Slices exist in relationship to each other. If you create one slice (called a *user slice*), Photoshop automatically divides the rest of the image into rectangular slices appropriately called *auto slices*. If you create even a single slice, the entire image must be sliced.

To create a slice with the Slice tool:

1. Select the Slice tool (grouped with the Crop tool).

2. Drag a rectangular slice on the image. Photoshop automatically creates auto slices everywhere else in the image.

To divide one slice into multiple even slices:

1. Select the existing slice with the Slice Select tool.

2. Click Divide in the options bar.

3. In the Divide Slice dialog box, select Divide Horizontally Into or Divide Vertically Into, and type the number of slices you want to create. If you prefer, you can specify how many pixels per slice instead.

Figure 9.3 *To divide a slice evenly into multiple slices, click the Divide button in the options bar.*

tip If you want all your slices to be the same size and evenly spaced, create a single user slice for the entire image. Then select the slice, and use the Divide button on the options bar to divide the original slice into as many vertical or horizontal rows of slices as you need.

To create slices based on layers:

1. In the Layers panel, select the layer you want to create a slice from.

2. Choose Layer > New Layer Based Slice.

If you create slices based on layers, Photoshop uses the dimensions of the layer for the slice and includes all its pixel data. When you edit the layer,

move it, or apply a layer effect to it, the slice automatically includes any new pixels.

 tip You can unlink a layer-based slice from its layer. To do so, select it with the Slice Select tool and click Promote in the options bar.

To create slices from guides:

1. Add guides to your image.

2. Select the Slice tool.

3. Click Slices from Guides in the options bar.

note If you create slices from guides, you're replacing any slices that already existed and any options associated with those slices; all you'll have are the slices from guides.

note You can create slices that have no content, and then add text or HTML source code to them. These are called No Image slices. You might want to use these so you that you can edit text in any HTML editor, without returning to Photoshop. However, if the text is too large for the slice, it can break the HTML table and result in unwanted gaps.

Editing slices

After you create a slice, you can select it with the Slice Select tool, and then move, resize, or align it. To select a slice, click it with the Slice or Slice Select tool. A gold bounding box indicates the selected slice.

Double-click a slice with the Slice Select tool to edit its attributes. In the Slice Options dialog box, you can name the slice, specify a URL, and enter a target. You can change the options for both user slices and auto slices, but if you change options for an auto slice, it becomes a user slice.

Figure 9.4

Be careful to enter the exact filename for your URL in the Slice Options dialog box. Otherwise, viewers will be frustrated when they click the link.

The URL is the page the slice links to. If you don't have the URL created yet, type the # sign so you can preview the slice's functionality without including an actual link.

The target determines whether the linked site opens in the same browser window or a new one. Type _self to display the linked file in the same browser window. Type _blank to open it in a new browser window.

Creating Animations

Animation is change over time. That sounds like a physics equation, but really it just means that, in an animation, something moves or is altered. You can create animations in Photoshop by modifying your image across time and exporting it as an animated GIF file or a QuickTime movie. The Animation panel contains a sequence of frames, with each frame varying slightly from the one that precedes it. Quickly viewing the frames creates the illusion of movement. For example, you might want an inner glow to gradually appear on an image, or you might want to shift a layer so that

text begins on the left side and ends on the right. Just about anything you can change in Photoshop, you can show in an animation.

 If you're creating an animation, use the Motion workspace, so you have easy access to the Layers and Animation panels.

To open the Animation panel, choose Window > Animation. The Animation panel originally displays a single frame of your current image.

Figure 9.5 *The Animation panel, displaying frames.*
A. Frames
B. Loop options
C. Select first frame
D. Select previous frame
E. Play
F. Select next frame
G. Tween frames
H. Duplicate frame
I. Delete frame
J. Convert to timeline
K. Animation panel menu

- To create frames from layers, choose Make Frames from Layers from the Animation panel menu.

- To modify an existing image for your animation, first duplicate it: select the existing frame in the Animation panel, and click the Duplicate Selected Frames button at the bottom of the Animation

panel. The new frame is based on the original. Now change that frame: add a layer effect, move a text layer, change the opacity, or make any other change that you want to animate. The changes you make are reflected in the duplicate frame.

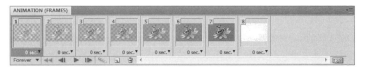

Figure 9.6 *Duplicate the frame and make changes to it.*

- To add frames that represent transitional stages between the two frames, use the Tween function. The word *tweening,* which comes from the traditional term *in betweening,* describes the process of adding or modifying a series of frames between two existing frames, varying the attributes that change evenly between the new frames. You can edit tweened frames individually after you create them.

To tween frames:

1. Select the first and last frames.

2. Click the Tween button at the bottom of the Animation panel.

3. In the Tween dialog box, specify how many frames to add between the two frames, whether to affect all the layers, and which parameters to affect (position, opacity, and effects).

4. Click OK.

Figure 9.7 *Tweened frames.*

If you select two contiguous frames, new frames are added between the frames. If you select more than two frames, existing frames between the first and last selected frames are altered by the tweening operation. If you select the first and last frames in an animation, these frames are treated as contiguous, and tweened frames are added after the last frame. (This tweening method is useful when the animation is set to loop multiple times.)

tip **In addition to frames, the Animation panel can display a timeline, in which each layer has its own line. To create a timeline, click the Convert to Timeline icon in the Animation panel. Conversely, to work with frame animation when you have multiple layers in an image file, click the Convert to Frame Animation icon.**

You can rearrange frames in the Animation panel as well. To move a frame, just drag it to a new position.

Click the Play button at the bottom of the Animation panel to test it. This previews the animation, though it may be a bit jerkier than it would be in a browser.

You can determine how many times an animation plays by selecting an option in the lower-left corner of the Animation panel. The default is once, but you can select 3 Times, Forever, or Other to enter your own number.

To save an animated GIF, choose File > Save for Web & Devices. Select a GIF preset, choose options in the Animation area in the lower-right corner of the dialog box, and then click Save.

Figure 9.8

Set looping options in the Animation section of the Save for Web & Devices dialog box.

To export a QuickTime movie, choose File > Export > Render Video. Then select the options you want to apply, and click Render.

Optimizing Images for the Web

How you balance image quality with image size depends on the image you're working with. The best format, resolution, and quality settings vary. Therefore, the Save for Web & Devices dialog box gives you the opportunity to preview different settings to see how they affect the size and quality of your image. You can apply different settings to different slices as well, saving file size where appropriate without sacrificing quality in more complex areas of the image.

JPEG , GIF, and PNG are the most common Web compression formats. As a general rule, use JPEG compression for continuous-tone images and GIF compression for broad areas of color.

To optimize an image for the Web:

1. Choose File > Save for Web & Devices.

2. Select a tab at the top of the dialog box to preview the original with an alternative or with three other options.

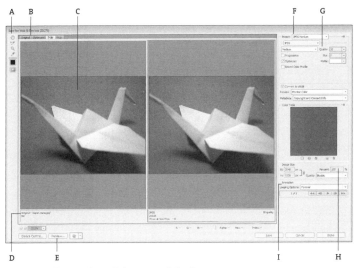

Figure 9.9 *The Save for Web & Devices dialog box.*
A. Toolbar
B. View tabs
C. Preview windows
D. File information
E. Preview in Web browser
F. Preset menu
G. Format settings
H. Image size
I. Animation options

3. Select a preset from the right side of the dialog box. A preset automatically selects a file format, algorithms, colors, dither percentage, and other options.

4. Compare the image quality in the preview windows. Also, note the file size listed beneath each preview window.

5. Select another preset, or adjust the settings to achieve the balance between quality and image size that works for you.

6. To modify the settings for a slice, select the Slice Select tool and then select a slice. Then select a preset from the right side of the dialog box, or adjust the format and its settings individually.

7. When you've found the combination that works best for your image, select that preview window, and click Save.

8. In the Save Optimized dialog box, choose HTML and Images to save the image (including any slices) and an HTML file that references the image and slices. You can also choose to save only the HTML file or only the images.

9. If you're saving slices, choose All Slices to save them all.

10. Name the HTML file and click Save.

note **If you want to save JPEG files to post to share online through Facebook or other photo-sharing sites, you can simply choose File > Save As, and then choose JPEG for the file format and set the appropriate JPEG compression options.**

10

Printing

It may seem old-fashioned, but you can actually print your photos from Photoshop—at home, on a desktop printer, through a photo-printing service such as Shutterfly or Costco, or by sending them to a professional service provider. Whether you're printing the photo itself or including it in another document that will be printed, it's a good idea to proof the image so you know what to expect.

And before you send the file anywhere, save a copy of the full file, with all its layers intact, so that you can edit it again for another purpose later.

Archiving Photoshop Files

You may need to convert an image to a different color mode for printing, or compress it in GIF or JPEG format for posting to the Web. Before you make any of those changes, though, make sure you save one full version, with all the layers and masks and filters and any other editable changes intact, so that you can return to the image and prepare it for another purpose later. Make sure you save it in PSD format.

How you archive the image depends on your general file organization, but consider creating a separate folder (backed up to a removable hard drive) just for these PSD files, so you'll be able to find them easily later and copy them for a new use.

Proofing Your Image

When you're printing an image, surprises are unwelcome and can be quite expensive. To anticipate any changes that might occur when you print, identify and correct out-of-gamut colors, and then preview the final results onscreen (called soft proofing).

Setting up color management

Your monitor displays colors in RGB, but professional printing usually uses CMYK (cyan, magenta, yellow, and black) inks, also called process inks. However, the RGB and CMYK color models both reproduce different *gamuts*, or ranges of colors. For example, you can produce neon colors in RGB, but not in CMYK; you can reproduce some pastels in CMYK, but not in RGB. Of course, pure black is also easier to represent with CMYK than with RGB, because CMYK includes a black ink.

The difference between RGB and CMYK gamuts is tricky enough. But the story gets more complicated because each monitor and printer model supports a slightly different gamut. So, to get the color you expect, it's important to use a color profile for your particular device that accurately defines the gamut it can reproduce.

Color management in Photoshop uses color profiles to convert colors from one color space to another. You select the color profiles for your devices to accurately proof and print your images. Photoshop can embed those profiles into your image files, so that Photoshop and other applications can accurately manage color as you work with the image.

Remember, though, that the color profile is only as good as the data it contains. Monitor displays can vary subtly, even within models, and they can change over time. To obtain accurate results from color management, calibrate your monitor and create a profile that captures the gamut of your monitor at that moment in time. For help calibrating your monitor, see Photoshop Help.

By default, Photoshop is set up for RGB as part of a digital workflow. If you're preparing artwork for print, however, change the settings to be more appropriate for printing.

To set up color management:

1. Choose Edit > Color Settings.

2. In the Color Settings dialog box, choose a preset from the Settings menu to select the appropriate working spaces and color-management policy options. North America Prepress 2, for example, uses settings for a typical prepress workflow. If you have custom profiles, select them in the Working Spaces area.

Figure 10.1

The Color Settings dialog box.

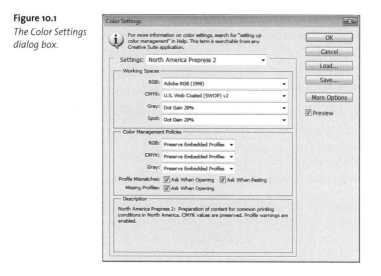

tip If you don't understand an option in the Color Settings dialog box, move the cursor over it and read the description at the bottom of the dialog box.

Soft proofing

To soft-proof an image, you need to set up a proof profile. The proof profile (also called a proof setup) defines how the document will be printed and adjusts its appearance onscreen to match.

To create a proof profile:

1. Choose View > Proof Setup > Custom.

2. In the Customize Proof Condition dialog box, select Preview.

3. From the Device to Simulate menu, choose a profile for your final output device. If you're sending the image out to be printed, obtain a profile from your print service provider.

4. Deselect Preserve Numbers, if it's selected. The Preserve Numbers option displays colors without converting them to the output device color space.

5. From the Rendering Intent menu, choose Relative Colorimetric.

 A *rendering intent* determines how the color management system makes the conversion from one color space to another. The standard rendering intent for printing in North America and Europe is Relative Colorimetric, which preserves the color relationships without sacrificing color accuracy.

6. If it's available for your chosen profile, select Simulate Paper Color, which automatically selects Simulate Black Ink as well.

 When you simulate paper color, Photoshop simulates the dingy white or real paper, according to the proof profile. When you simulate black ink, Photoshop simulates the dark gray that actually prints to most printers, instead of solid black.

7. Click OK.

When you set up a custom proof profile with Preview selected, it automatically displays the image with the proof profile. To toggle the proof profile, choose View > Proof Colors, or press Ctrl+Y (Windows) or Command+Y (Mac OS).

Identifying out-of-gamut colors

RGB images often contain some colors that are outside the CMYK gamut, so it's a good idea to identify those colors before printing. That way, you

can make changes to the image that are acceptable to you, instead of trusting the conversion to make the appropriate changes.

To view out-of-gamut colors, choose View > Gamut Warning. Photoshop displays a neutral gray in the image window where the colors are out of gamut.

Figure 10.2
Colors that don't fall into the range supported by your targeted printer appear gray onscreen.

tip To make the out-of-gamut display more visible, you can change its color by choosing Edit > Preferences > Transparency and Gamut or Photoshop > Preferences > Transparency and Gamut, and then selecting a color in the Gamut Warning area.

To correct out-of-gamut areas, make temporary changes while Proof Colors is selected. Make the changes nondestructively, so that you aren't affecting the underlying image. Often, using a Hue/Saturation adjustment layer is a good choice, because you can target a specific color range. To edit a specific portion of the tonal range using a Hue/Saturation adjustment layer, select a color group from the pop-up menu (for example, Reds), and then drag the sliders at the bottom of the panel

to include a very small portion of the spectrum. You can also drag the targeted adjustment tool to modify specific areas.

 tip **Name the adjustment layer for the device you're printing to, so you'll remember to use it again if you print to the same device later—or to hide it if you target a different device.**

Printing a hard proof

If you want to hold the proof in your hand, rather than trust your monitor, you can print a hard proof. Your print service provider may print one, calling it a *proof print* or a *match print*. A hard proof is printed to a device that's less expensive than a printing press, but for an accurate hard proof, make sure you're printing to a device that can support high-resolution printing.

To print a hard proof:

1. Choose View > Proof Setup > Custom.

2. From the Device to Simulate menu, select the final output printer (not the device to which you're printing the hard proof). Click OK.

 tip **If you want to use your custom proof setup again later, click Save to save it. It will appear in the View > Proof submenu after you save it.**

3. Choose File > Print.

4. Choose Color Management from the pop-up menu on the right side of the dialog box.

5. Select Proof. The profile that appears next to it matches the one you selected in the proof setup.

6. From the Color Handling menu, choose Photoshop Manages Colors.

7. From the Printer Profile menu, select the profile for the device you're actually printing to.

8. Click the Print Settings button.

9. In the Print dialog box that appears, access the printer driver options, and turn off color management for the printer so that the printer profile settings don't override your profile settings.

note **Printer drivers have different color management options. You may need to consult your printer documentation to determine how to turn off color management.**

10. Click Print.

Printing to a Desktop Printer

If you're printing photos to share with friends or family, you'll probably want to use your home desktop printer. You can proof the image onscreen before printing to a desktop printer, too, saving ink and photo paper. Follow the instructions in the soft-proofing section, but make sure to select the profile for your local printer.

To print to a desktop printer:

1. Soft-proof the image, and then make any changes you need to make.

2. Choose File > Print.

3. Choose Color Management from the pop-up menu on the right side of the Print dialog box.

4. Select Document.

5. From the Color Handling menu, choose Photoshop Manages Colors.

Figure 10.3
The Print dialog box.

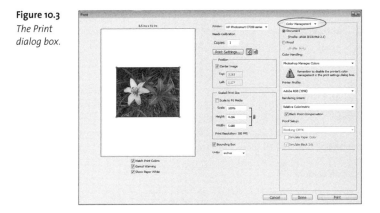

 If you don't have a profile for your printer, you may prefer to choose **Printer Manages Colors.**

6. Choose the profile for your printer from the Printer Profile pop-up menu.

7. Select Match Print Colors under the preview window so you can soft-proof right there, within the Print dialog box.

tip You can scale an image using options in the Print dialog box. The shaded area in the preview window represents the margins of the selected paper; the printable area is white. If you scale the image in the Print dialog box, it affects the size and resolution of the printed image, but leaves the Photoshop file untouched. Keep an eye on the print resolution noted in the Scaled Print Size area to make sure you're not compromising quality too much by scaling the image up.

8. If all is well, click Print.

9. In the Print dialog box that displays your printer's settings, turn off the printer's color management, and select the appropriate paper stock, print quality, and any other settings.

10. Click Print.

> **tip** If you're going to print to a typical inkjet desktop printer, keep the image in RGB mode. Usually, desktop printers accept RGB data and use internal software to convert to CMYK. Sending CMYK data results in double conversion with unpredictable results.

Preparing to Print an Image Professionally

Whether you're sending your files to a full-service print provider for output on a printing press or uploading them to a quick printer such as Shutterfly or Costco for standard photo prints, you should take a few minutes to prepare your image and make sure you'll get the results you want. Proof the image, make any changes, and then duplicate and flatten the image so that others can't accidentally tweak layers and settings.

Follow these steps for the best results:

1. Find out what device your image will be printed to, and obtain the appropriate device profile.

2. Soft-proof the image.

3. Make any changes to ensure you'll get the results you want. Use nondestructive techniques, such as adjustment layers, so you can modify the image differently for another purpose later.

4. Save a copy of the file to a folder that names the print service— or include the print service name in the filename so you'll remember later.

5. Choose Image > Duplicate.

6. Select Duplicate Merged Layers Only, and click OK.

 If the bottom layer was called Background, Photoshop automatically flattens the file. If the bottom layer wasn't Background, choose Flatten Image from the Layers panel menu to flatten the layers.

7. Choose Edit > Convert to Profile.

8. In the Convert to Profile dialog box, choose the destination profile for the device you'll be printing to. Then click OK.

9. Choose File > Save. Save the image in the format the service provider recommended, such as JPEG or TIFF. Select Embed Color Profile, and select the maximum quality possible.

 Some printers may prefer to receive your documents in PDF format. You can save a file in Photoshop PDF format.

 If you know from the outset that you'll be sending an image for commercial printing, contact your provider to learn its requirements. The provider may recommend a workflow that you'll want to follow as you edit the image.

Organizing Images in Bridge

In the age of digital photography, we all have too many photos to keep track of easily. Adobe Bridge can help you wrangle your images and find the ones you're looking for.

Adobe Bridge is included with all the Creative Suite applications except Adobe Acrobat. It's a handy application whether you just want to browse thumbnails of your photos or need to search on metadata, including keywords. You can use it to open images directly in Adobe Camera Raw, instead of Photoshop—and you can even access some of Photoshop's neatest features (such as Photomerge) directly from Bridge. In addition to adding and searching metadata, you can rank and group images, so there's an organizational method for just about everyone.

Importing Images into Bridge

Use the Photo Downloader utility to download images from your camera or memory card onto your hard drive. They'll automatically appear in Bridge, so you can review and organize them, or go right into photo-editing mode!

Figure 11.1

The Photo Downloader utility can transfer images from your camera to your hard drive and show them in Bridge.

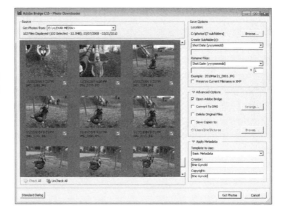

To download photos in Bridge:

1. Connect your camera to your computer or insert your memory card.

2. Choose File > Get Photos from Camera.

3. Choose a location on your hard drive for the photos; you can create a new folder for them using a date format or your own custom name.

4. If you want to rename the files, select a name format.

5. If you want to be selective about which images you download to your system, click Advanced Dialog, and then select the ones you want to include.

 The Advanced dialog box also lets you apply a metadata template or just creator and copyright information as you download the files.

6. Click Get Photos. *Voilà!*

Viewing Files in Bridge

Adobe Bridge is an Adobe application, so there are plenty of panels involved. By default, the ones you're most likely to need are already open, including:

- The **Favorites and Folders panels,** which you use to navigate to the files you're interested in

- The **Content panel,** which displays everything in the selected folder

- The **Preview panel,** which gives you an isolated view of the selected image or file

- The **Metadata panel,** which displays additional information about the selected file

- The **Keywords panel,** which lists the keywords associated with the file

- The **Filter and Collections panels,** which make it easier to find specific files

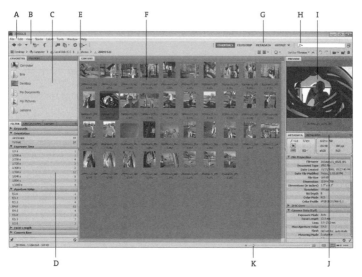

Figure 11.2 *Adobe Bridge displays your images, as well as a wealth of information about them.*

A. Menu bar

B. Application bar

C. Favorites and Folders panels

D. Filter and Collections panels

E. Breadcrumbs

F. Content panel

G. Workplace Switcher

H. Search box

I. Preview panel

J. Metadata and Keywords panels

K. Thumbnail slider

Just like Photoshop, Bridge includes workspaces, designed to display panels in a configuration most efficient for a particular task. Select a workspace from the Workspace Switcher in the application bar, or

choose one from the Window > Workspace submenu. If you want to emphasize the preview as you scroll through images, select the Filmstrip workspace. To create a Web gallery, use the Output workspace. For most tasks in Bridge, the Essentials workspace works just fine.

Of course, if you want to create your own workspace, you can. Configure the panels however you like (drag them to reposition or resize them; open new ones by choosing Window > [panel name]; close the ones you don't want). Then choose Window > Workspace > New Workspace, name it, and enjoy it.

Figure 11.3
The Filmstrip workspace displays images across the bottom, with a prominent Preview panel.

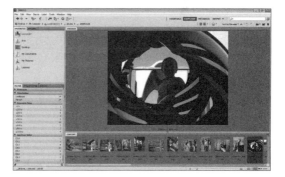

The Favorites panel is especially useful if you're likely to return to the same folders (say, a Photos folder or a Projects folder) over and over. To add a folder to the Favorites panel, navigate to the folder in the Folders panel, and then choose File > Add to Favorites. Or select the folder in the Content panel and then drag it into the Favorites panel.

To see a full-screen preview of an image, select its thumbnail in the Content panel, and then choose View > Full Screen Preview, or just press the spacebar.

tip To view a slide show of the contents of selected thumbnails or of an entire folder (currently displayed in the Content panel), choose View > Slideshow or press Ctrl+L (Windows) or Command+L (Mac OS). To set options, including how long each image stays on the screen and what the transitions look like, choose View > Slideshow Options.

Adding Metadata

Metadata is information about a file, including keywords, the date the file was created, the name of the person who created it, copyright information, its resolution, its color space, and so on. When you download a photo from a digital camera, metadata comes along with it. You can view that information in Bridge, in the appropriately named Metadata panel. Some metadata is fixed; you can't edit the creation date or bit depth in Bridge, for example, because it would no longer be accurate. However, you can edit a great deal of information.

tip You can choose which metadata fields are included in the Metadata panel. Choose Edit > Preferences (Windows) or Adobe Bridge CS5 > Preferences (Mac OS). Then select Metadata from the list on the left. Select the fields you want to include.

To add or edit the content of a metadata field, click the pencil icon to the right of it. Then enter the information, such as your address or contact information, or a description of the image.

tip If you're working with medical images, such as X-rays and CT scan data, use the DICOM section in the Metadata panel to record patient and study information.

Figure 11.4

Some metadata is captured by your camera; other metadata you can enter or edit yourself.

Adding Keywords

You can enter keywords in the Metadata panel, but working with keywords is easier in the Keywords panel.

Bridge provides default keyword categories to get you started: Events, People, Places, and Other Keywords. You can add your own keywords to each of these categories, or create categories of your own. Actually, *categories* is my word—Bridge calls the categories *keywords,* and it refers to keywords grouped under them as *sub keywords.* You can search on the categories themselves, so technically, they are, in fact, keywords in their own right. But I prefer to refer to categories and keywords to reduce confusion.

Figure 11.5

Create keywords and categories that are meaningful to you.

To add a keyword to an existing category:

1 Select the category name.

2. Choose New Sub Keyword from the Keywords panel menu, or click the New Sub Keyword icon (which looks like a plus with an indent) at the bottom of the panel.

3. Type the keyword.

To add a new category:

1. Choose New Keyword from the Keywords panel menu, or click the New Keyword icon (a plus sign) at the bottom of the panel.

2. Type the category name.

To apply keywords to images:

1. Select the image or images to which you want to apply the keywords.

2. Click next to the keywords in the Keywords panel that you want to assign. You can select the category name (or main-level keyword) separately.

Searching with Metadata

Metadata can provide useful information about images you're previewing, but it's even more useful as an aid to finding the images you want. If you've invested the time to create meaningful keywords and add useful image descriptions, you can locate images in Bridge quickly.

To search for photos by keyword:

1. Select the folder you want to search. If you want to search your entire hard drive, select the name of your hard drive in the Folders panel.

2. Enter the keyword in the search field in the upper-right corner of the Bridge window. Keywords are not case sensitive.

3. Press Enter or Return. All files with the associated keyword appear in the Content pane.

Figure 11.6
To search for photos with a specific keyword, enter it in the Search field.

To search based on other metadata or on multiple keywords:

1. Select the folder you want to search. Unfortunately, you can only filter one folder at a time.

2. In the Filter panel, select the criteria in each category that you want to see.

Criteria in categories are cumulative so, for example, if you select "Sally" under Keywords and "Landscape" under Orientation, you'll see only landscape images with the keyword *Sally.*

However, criteria within a category are noninclusive. If you select both "Sally" and "Cats" under Keywords, you'll see images that have either the keyword *Sally* or the keyword *Cats* or both.

Figure 11.7

Select criteria in the Filter panel to limit which files appear in the Content panel.

Creating Collections

Collections are groups of images, gathered from anywhere on your hard drive. Once you've created a collection, anytime you select it in the Collections panel, Bridge displays the files in the collection.

To create a collection:

1. Select the files you want to include.

2. In the Collections panel, click the New Collection button at the bottom of the panel.

3. Click Yes when asked if you want to include the selected files in the collection.

4. Name the collection.

To add a file to a collection, just drag it from the Content pane onto the collection name in the Collections panel.

tip **You can let Bridge create collections for you, called Smart Collections. Click the Create Smart Collection button at the bottom of the Collections panel. Select the folder to search (and it can include subfolders), and specify the criteria to use, such as specific keywords. Then name the collection. Note that you can't add files manually to the Smart Collections.**

Labeling Images

There's yet another way to classify and locate images in Bridge: rankings. You can apply a rating of one to five stars to any document. To apply a rating, select the file, and click a dot beneath its thumbnail. Click the first dot to apply one star, the fourth dot to apply four stars, and so on. Alternatively, you can select the image, and choose Label > [star rating]. You can also label an image with Reject, making it easier to delete those later.

Figure 11.8
Star ratings appear under images, if the thumbnails are large enough in the Content panel.

eagle_sculpture_seattle..psd

Figure 11.9
The Reject label appears in red beneath an image.

In addition to star ratings, you can apply your own colored labels to files. Select a thumbnail, and then choose Label > [label name], or use the keyboard shortcuts to apply the label. To change the label names, enter new ones in the Preferences dialog box. Choose Edit > Preferences (Windows) or Adobe Bridge CS5 > Preferences (Mac OS). Then select Labels in the list on the left, and enter a name for each label.

Figure 11.10
You can customize label names in the Preferences dialog box.

To view images with a particular rating or label, select the label or rating in the Filter panel.

Stacking Images

If your folders are stuffed full of images, consider grouping similar files in stacks, so it's easier to see what's in the Content panel.

To create a stack:

1. Select the images you want to include in the stack. Usually, it makes sense to stack images that were taken at the same time, or that are similar in some other way.

2. Choose Stacks > Group as Stack.

You can tell when you encounter a stack because there's a number in the upper-left corner of the thumbnail; the number indicates how many images are in the stack.

Figure 11.11
A small number badge indicates that images are stacked.

To see all the images in the stack again, just click the number in the upper-left corner of the stack. Bridge displays the images with a border so you can see which images remain part of the stack. To close the stack, click the number again.

You can add metadata or keywords to an entire stack at once. You can also use a stack to create a panorama.

If you decide you want to free your images from the stack permanently, select the stack and choose Stacks > Ungroup from Stack.

Jumping Off from Bridge

Just to be clear: that's jumping off *from Bridge,* not jumping off *a bridge.* Bridge provides a handy way to organize and preview your images, but it's also a gateway to other Adobe applications.

To open an image in Photoshop, double-click its thumbnail in Bridge. Bridge determines which application to open based on the file-type associations listed in its Preferences dialog box.

 If you've previously edited the file in Camera Raw, a JPEG or TIFF image might open in Camera Raw instead.

To open a JPEG, TIFF, or raw format image in Camera Raw, select it in Bridge, and choose File > Open in Camera Raw.

To apply a Photoshop feature such as Photomerge or Lens Correction to images, select them and choose Tools > Photoshop > [feature]. Bridge opens the files in Photoshop and automatically applies the feature.

Figure 11.12
Commands in the Tools menu provide a shortcut to some Photoshop features.

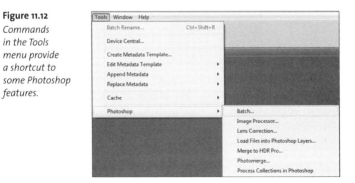

If you have other Adobe Creative Suite applications installed, you can access their features through the Tools menu in Bridge as well.

12

Automating Tasks

There are some things you do over and over again in Photoshop, as if you were working on an assembly line. But if there are tasks that you perform frequently, why not let Photoshop take care of the tedious stuff? Automation features, including actions and droplets and scripts, accomplish routine tasks quickly so that you can get back to being creative. For example, you can easily convert a bunch of images to grayscale using the same settings, apply a new color profile to an entire folder of images at once, or apply standard sharpening values to a collection of photos.

Playing Actions

The simplest way to automate tasks is to record and play actions. An *action* is a recorded set of steps that you play back to apply them to one or more files.

Actions live in the Actions panel (choose Window > Actions). There are already a bunch of them in there, grouped in the Default Actions set. You can play these actions to apply a sepia tone or vignette, save an image as a Photoshop PDF, or convert images to grayscale.

To play an action, open the image you want to apply it to, and then select the action and click the Play button in the Actions panel. You can expand an action to see the individual steps included in it.

Figure 12.1

You can view the steps in an action in the Actions panel.

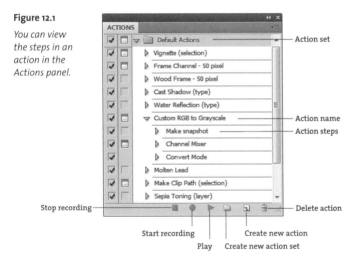

To apply actions to multiple files at once:

1. Open the files you want to apply the action to. (You don't need to do this if you'll be applying the action to an entire folder's worth of files.)

2. Choose File > Automate > Batch.

3. In the Play area of the Batch dialog box, choose an action set, and then choose the action you want to run.

Figure 12.2
The Batch dialog box.

4. If you want to apply the action to files you opened, choose Opened Files from the Source menu. Otherwise, choose Folder and specify a folder that contains the files you want to apply the action to. Photoshop will run the action against all the files in the folder that it can open.

5. Choose an option from the Destination menu. You can have Photoshop save and close the files after it applies the action, or save them to a folder you specify.

6. Click OK to run the action for all the files you've specified.

Recording Actions

Some of the default actions can be handy, but what makes the feature so powerful is that you can record your own actions.

To create a new action set, click the Create New Set button in the Actions panel, name the set, and click OK.

To record an action:

1. Click the New Action button.

2. Name the action, select an action set to group it in, and then click Record.

3. Perform all the tasks that you want to include in the action. Take all the time you need to record the action accurately. The time it takes you to record the action has no effect on the time it takes to run.

 If you mess up, click the Stop button in the Actions panel, delete the action, and start over.

4. When you're done, click the Stop button.

If you're recording a straightforward, action such as coloring a text layer red, you can probably go straight to recording. But if you're recording an action that involves multiple sophisticated steps, take the time to think through the process, and then rehearse the steps to make sure you're doing them in the right order. Note the steps for yourself, so you'll have a guide as you record the action.

Creating Droplets

Droplets take actions a step further. Using a droplet, you can apply an action to a file without even opening it.

To create a droplet:

1. Choose File > Automate > Create Droplet.

Figure 12.3
*Create a droplet
to apply actions
to files on
your computer
without opening
Photoshop.*

2. In the Create Droplet dialog box, choose an action from an action set.

3. From the Destination menu, choose whether you want to save and close the file, move it to a new folder, or neither.

- If you choose Folder, click Choose and then select the folder for the newly saved files.

- If you choose Save and Close, Photoshop saves each file with its original name and closes it, leaving it in the original folder.

- If you choose None, Photoshop honors any Save or Close commands in the action. If there are none, it leaves the files open.

4. If you chose Folder, set up the file-naming protocol for the newly saved files. You can append a file extension, date, or serial number to each image.

5. Select any options you want to apply. You can override any Open commands in the action, apply the action to files in all subfolders of the folder you drop the droplet on, suppress file open options dialog boxes and color profile warnings so the action won't be interrupted (defaults will be accepted), or override Save As commands in the action. You can also stop the action when it runs into errors or have it keep going and log the errors so you can refer to them later.

6. Click OK.

7. To use the droplet, drag an image or folder of images onto the droplet in Explorer (Windows) or the Finder (Mac OS).

Using Scripts

You can take automation even further by creating your own scripts for Photoshop. It supports scripting languages such as VB Script in Windows and AppleScript in Mac OS. You can also use JavaScript to write scripts that work with either Windows or Mac OS.

I don't have either the space or the expertise to tell you how to write your own scripts here, but some pretty fantastic resources are available online. Photoshop mavens not only provide scripting tutorials, but they share sample scripts that you can copy and use as they are or use as the basis for your own custom scripts. A quick Web search on "Photoshop scripts" should get you on your way.

Photoshop automatically includes some scripts without any effort on your part. You can delete all empty layers, export layers to files, and perform other tasks using scripts that are already installed.

To run a script, choose File > Scripts, and then select a script.

If you copy or write additional JavaScript scripts, save them with a JS or JSX extension to the Photoshop CS5/Presets/Scripts folder. They'll show up automatically in the Scripts submenu.

 If you want to use a script saved elsewhere on your system, choose File > Scripts > Browse, and then navigate to the script you want to run.

Creating Presets in Camera Raw

Automation isn't just for Photoshop. You can apply sets of adjustments to images in Camera Raw.

To create a preset:

1. In Camera Raw, apply the adjustments you want to include in the preset.

2. Click the Presets tab.

3. Click the New Preset button at the bottom of the Presets panel.

4. In the New Preset dialog box, name the preset, select which settings you want to include in the preset, and then click OK.

To apply a preset, do one of the following:

- Click its name in the Presets panel in Camera Raw.

- Select an image in Bridge, and then choose Edit > Develop Settings > [preset name].

Appendix: Resources

This book is a pocket guide, meant to be a handy reference and a starting place for Photoshop exploration. But you're bound to have questions that aren't addressed here, and there's a whole world of inspiration, techniques, and tutorials that you can access.

Troubleshooting

When you're looking for answers about something that's gone wrong—error messages or strange behaviors—the Adobe Support Knowledgebase is the place to go. Chances are good that someone else has run into the same problem and the helpful people at Adobe have figured out a solution for you. Visit www.adobe.com, and then choose Support > Knowledgebase from the menu at the top. You can choose any Adobe product and search on any terms to see what comes up in the database.

You can also communicate with other Photoshop users online, through the Adobe user forums. Search for answers and read existing threads as a guest, or log in to ask your own questions or contribute your own advice at www.adobe.com/forums.

Factual Information

When you stumble upon a tool, filter, or blending mode, and you want to know what it does, Photoshop Help and the broader Adobe Community Help can give you straightforward information. You'll find both on the Adobe Web site at www.adobe.com/support/photoshop.

 tip You can also get there quickly by choosing Help > Photoshop Help from within the application.

Inspiration and Tips

When you want to stretch your creativity, learn how to use Photoshop more efficiently, or find inspiration, there are countless resources ready to engage you.

Adobe TV

A good place to start is Adobe TV at http://tv.adobe.com. Adobe hosts hundreds of videos to help you get the most from Adobe software. Go to Adobe TV and search on whatever you want to learn more about. Or browse by product or channel (including channels devoted to photo edit-ing, inspiration, and Web design) to see what's available.

Figure A.1
Adobe TV offers something for everyone who uses Adobe applications.

Here are some shows you'll want to be sure to check out:

- The Russell Brown Show

 http://tv.adobe.com/show/the-russell-brown-show

- Dr. Brown's Photoshop Laboratory, Episode: Printing Experiments

 http://tv.adobe.com/watch/dr-browns-photoshop-laboratory/printing-experiments

 Learn how to set up your printer, calibrate your monitor, and adjust the software settings for the finest print result.

- The Complete Picture with Julieanne Kost

 http://tv.adobe.com/show/the-complete-picture-with-julieanne-kost

- Everyday Timesavers: Photography

 http://tv.adobe.com/show/everyday-timesavers-photography/

More inspiration

In addition to Adobe TV, you'll find time-saving tips and professional techniques at the following Web sites:

- www.russellbrown.com/tips_tech.html

- www.photoshopuser.com

- www.photoshopcafe.com

- www.planetphotoshop.com

 Search "Photoshop" plus any other word to find numerous other sites of interest on the Internet.

If you prefer books, browse the offerings from Adobe Press and Peachpit Press at www.peachpit.com. There are books for every learning style— and for every aspect of working with Photoshop, photography, and design.

You can also learn from other people who use Photoshop personally or professionally. Adobe doesn't host formal Photoshop user groups, but enthusiastic Photoshop users meet all over the country to share their experience with each other and to learn from guest speakers and designers. Search "Photoshop user group" plus your city name on the Web and see what you get. If nothing comes up, start your own!

Index

WATCH
READ
CREATE

Meet Creative Edge.

A new resource of unlimited books, videos and tutorials for creatives from the world's leading experts.

Creative Edge is your one stop for inspiration, answers to technical questions and ways to stay at the top of your game so you can focus on what you do best—being creative.

All for only $24.99 per month for access—any day any time you need it.

creative edge

creativeedge.com